C000241175

GOSPORT

From Old Photographs

JOHN SADDEN

AMBERLEY

First published 2011

Amberley Publishing
The Hill, Stroud
Gloucestershire, GL5 4EP

www.amberley-books.com

Copyright © John Sadden 2011

The right of John Sadden to be identified as the Author
of this work has been asserted in accordance with the
Copyrights, Designs and Patents Act 1988.

All rights reserved. No part of this book may be reprinted
or reproduced or utilised in any form or by any electronic,
mechanical or other means, now known or hereafter invented,
including photocopying and recording, or in any information
storage or retrieval system, without the permission in writing
from the Publishers.

British Library Cataloguing in Publication Data.
A catalogue record for this book is available from the British Library.

ISBN 978 1 84868 147 7

Typesetting and Origination by Amberley Publishing.
Printed in the UK.

Contents

Acknowledgements

Thanks are especially due to Peter Greenaway, whose collection of Gosport and Lee-on-the-Solent postcards is probably the best in the borough. Thanks also to the Hug family, Stephen Weeks, the late Norman and Grace White, Geraldine Whittle, Roger Black, Mrs Hague, Mrs J Plummer, G Reynolds, Jean-Luc, Paul Holloway, National Library of Australia, Dr Neil Clifton, Portsmouth Grammar School Archive, Carl Van Vechten Collection, George Grantham Bain Collection, Mr R. A. Lowe, Ann Widdecombe and Barry McCann. Acknowledgement is made to the local photographers of the past. The town is particularly fortunate in having been the subject of the photographers J. C. Lawrence & Sons, whose family members have left us a rich diversity of material.

Beside the Sea

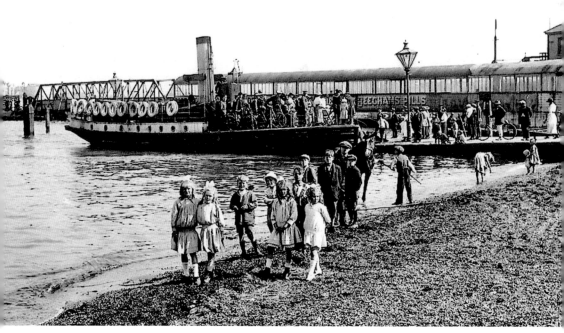

Gosport ferry, 1920s. Workmen with their cycles prepare to disembark from the *Ferry King*. This 57-ton steam launch was built by Camper & Nicholson in 1918 and served local commuters reliably and cheaply until 1960.

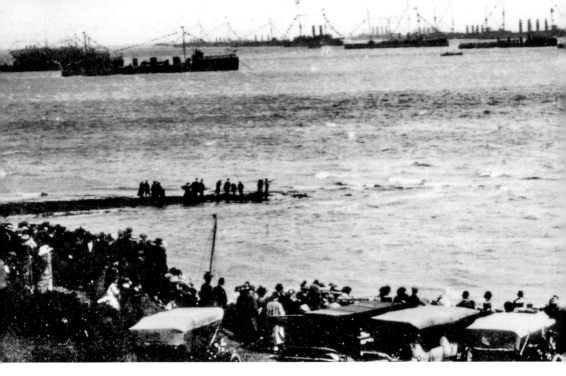

View from Gilkicker Point, July 1914, a few weeks before the outbreak of the First World War.

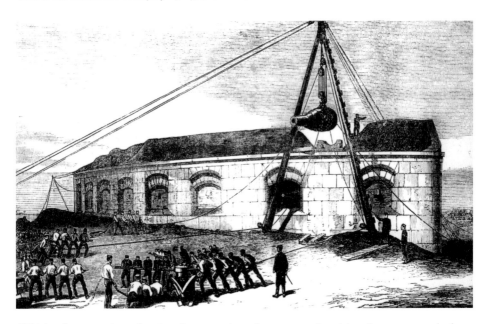

Gilkicker battery, 1879, showing the mounting of a .25 gun. In 1863, plans were made for a mortar battery to be established on the site to protect against any invading fleet. In 1869, an 'overhead mechanical travelling shell-bearer' was invented by Henry Cunningham of Bury House, Gosport, for use at Gilkicker, enabling one man to move a 9-inch shell weighing 250lbs to the gun – a procedure which had previously required four men. This was later adopted elsewhere. In the 1850s, the inventive Mr Cunningham had promoted a method of reefing ships' sails without sending men aloft, which was used extensively in British troopships.

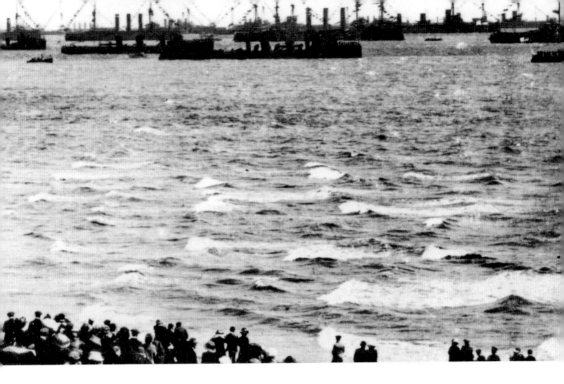

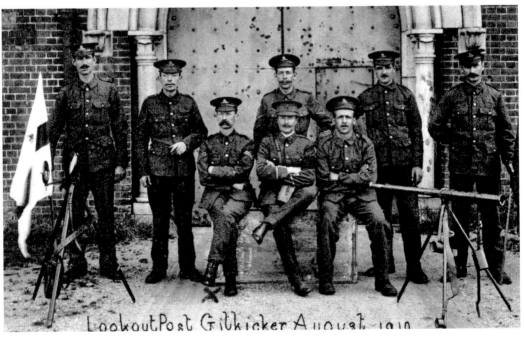

Lookout Post Gilkicker August 1910

Gilkicker, 1910. In 1906, the recommendation was made to disarm the fort and, after reconstruction, its barrack blocks were converted to married quarters for the Royal Engineers and Royal Artillery. The following year the breech loading guns were dismounted but, following the attack on Portsmouth by a Zeppelin in 1916, an anti-aircraft gun was installed. The fort was finally vacated by the Royal Engineers in 1956.

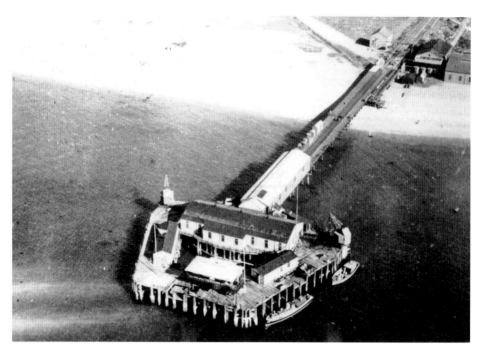

Stokes Bay Pier, 1930s. The pier was built in 1862/63 to enable passengers to travel by steamer to the Isle of Wight.

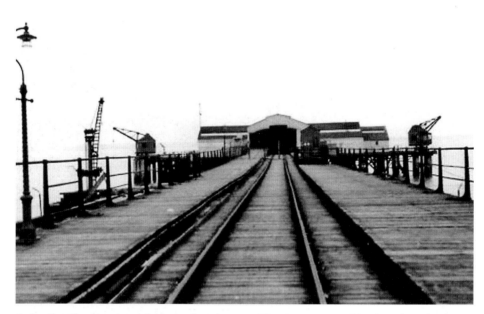

Stokes Bay Pier, showing railway track and cranes. The pier was rented by the Admiralty during the First World War and subsequently rebuilt as the Torpedo Experimental Station, a part of HMS *Vernon*. The cranes were used for lifting torpedoes. The pier was demolished in the 1970s and its supports finally removed by the Royal Engineers in the mid-1980s.

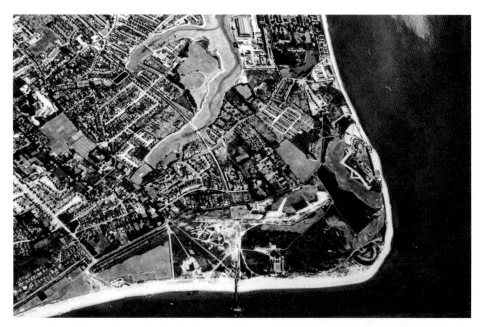

Aerial view, *c.* 1965, showing the pier, Fort Gilkicker and Fort Monckton. The School of Electrical Lighting is visible between the pier and Fort Gilkicker; here, work and training was carried out by the Royal Engineers on electrical engineering, mainly searchlights.

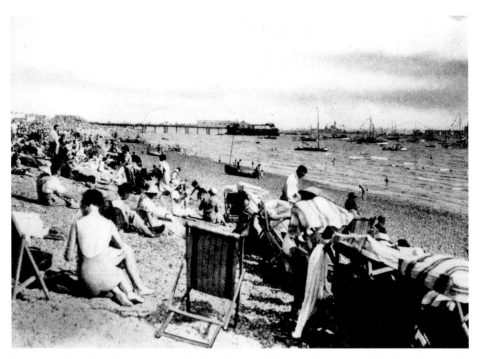

Stokes Bay beach and pier *c.* 1937, during what is believed to be the Fleet Review of 1937, the last before the Second World War.

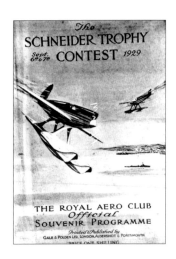
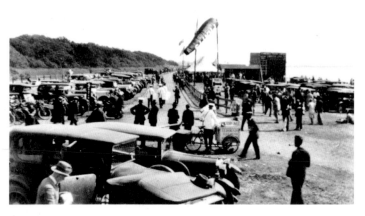

Above left: The Schneider Trophy Contests of 1923, 1929 and 1930 were held in the skies over the Solent and Stokes Bay was the best vantage point for spectators. The line of flight crossed directly over Fort Monckton and Stokes Bay Pier to a point just north of West Cowes. The race was instrumental in improving aerodynamics and engine design, contributing to the success of the best fighter planes of the Second World War, including the Spitfire, which was largely made at the Supermarine works at Woolston.

Above right: Stokes Bay during the Schneider Trophy Contact of September, 1929. This photograph, showing an Eldorado ice cream seller sending two colleagues for fresh supplies, was taken by Mr R. A. Lowe, a joiner, who helped construct a spectators' stand at the event.

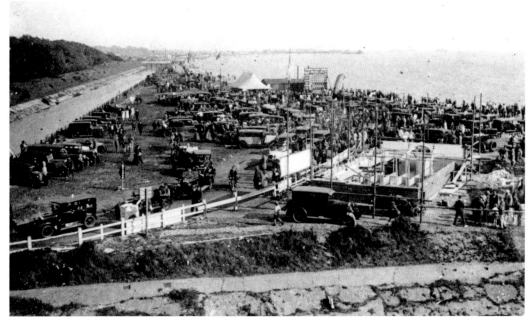

Stokes Bay, 1929: a view taken from No. 2 Battery. The scoreboard, visible just below the pier, would have later displayed Great Britain's victory, with Flying Officer H. Waghorn clinching it with an average speed of 328.63 mph.

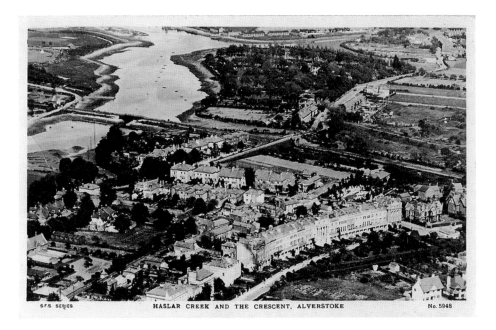

S.F.S. SERIES HASLAR CREEK AND THE CRESCENT, ALVERSTOKE No. 5948

Haslar Creek and the Crescent as it would have been seen by Schneider Trophy contestants. A similar view from a more easterly point appears on p. 125.

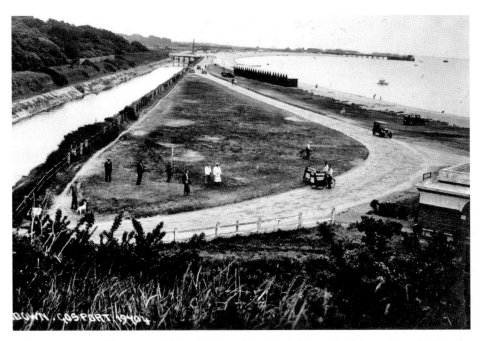

Stokes Bay, 1930s. The moat, fed by the River Alver, is visible on the left, and was built in the 1850s to deter the French, but later attracted children with hand-lines hoping to catch tiddlers. A popular habitat for nesting swans, the moat was filled in during the 1960s. Ice cream sellers with ice-boxes mounted on bicycles seek trade. On the right are the recently completed public toilets, seen under construction in the photograph to the left.

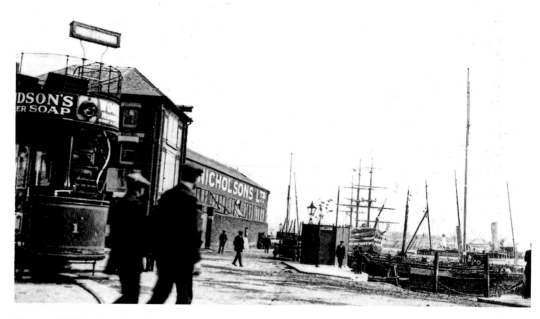

Camper & Nicholson, boat-builders, is on the left of this view across Portsmouth Harbour, *c.* 1910. On the left is tram No. 1, one of the fleet of electric trams that replaced horse-drawn trams in 1906.

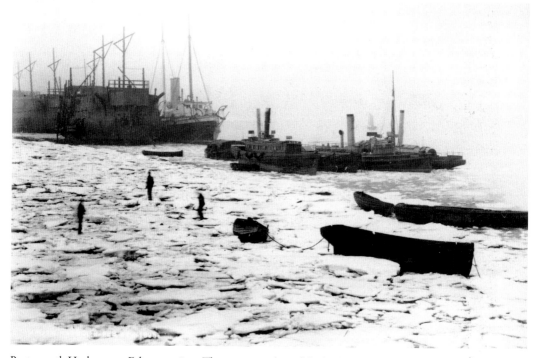

Portsmouth Harbour, 12 February 1895. The upper reaches of the harbour were completely frozen over for the first time since 1855.

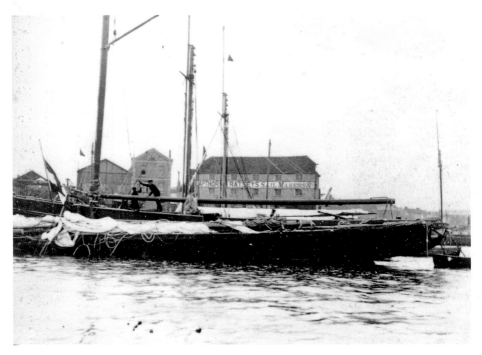

Ratsey & Lapthorn's sail loft, seen here in the late nineteenth century, was established in 1796, destroyed in an air raid in January 1941 and rebuilt in 1949.

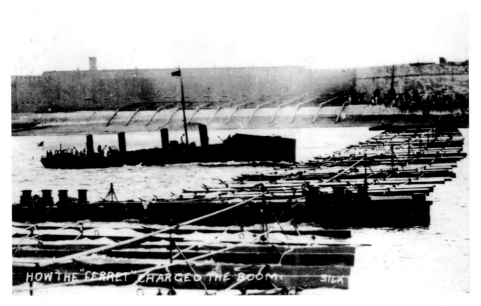

HOW THE "FERRET" CHARGED THE BOOM. SILK

Testing the boom defence, Portsmouth Harbour, 1909. HMS *Ferret*, with a skeleton crew of brave volunteers, is seen here ramming the boom defence, which stretched from Portsmouth to Gosport across the mouth of the harbour. Designed to prevent enemy vessels entering, the reinforced bows of the *Ferret* cut through the defence with ease.

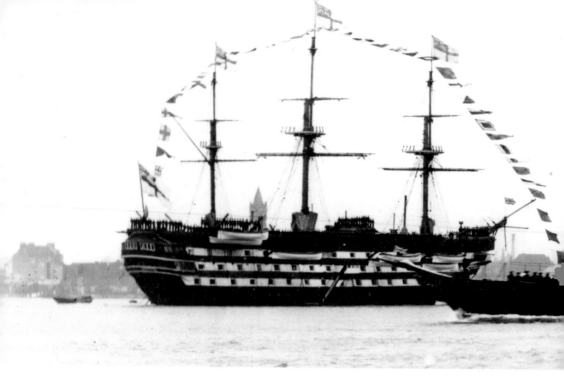

The Royal Yacht tender *Alberta* leaves Portsmouth Harbour in 1902 with the newly crowned king, Edward VII, aboard. It was probably headed for Osborne House. Boys of HMS *St Vincent* line the decks of the training ship moored off Gosport.

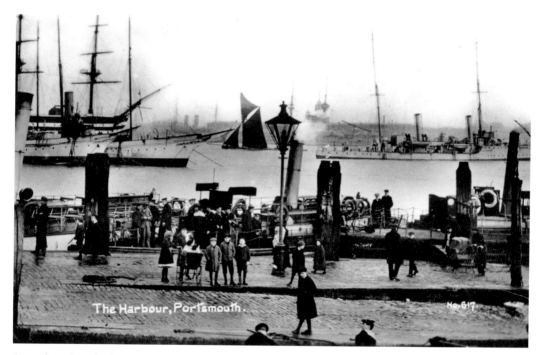

The Harbour, Portsmouth.

Steam launches ply their trade across the harbour, *c.* 1912. Children pose for the photographer, one of them precariously in charge of a pram, on the sloped Hard.

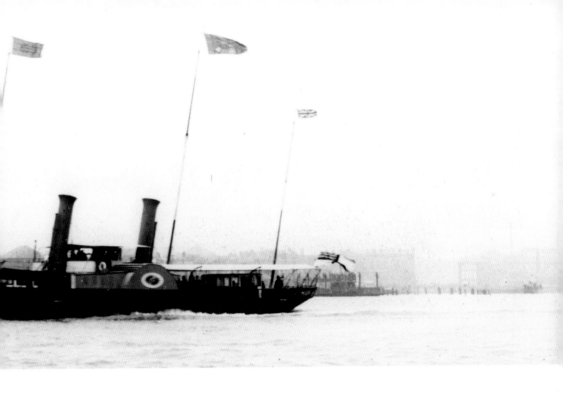

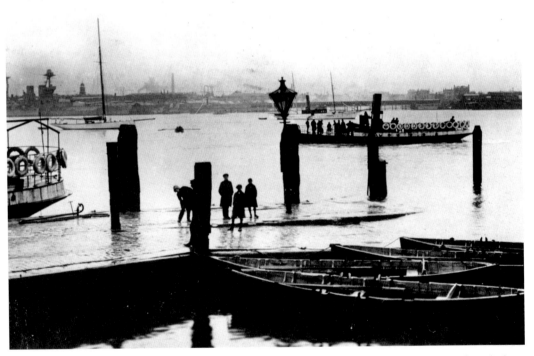

Rowing boats belonging to the Gosport Watermen are moored at the Hard, while a steam launch chugs past, *c.* 1920

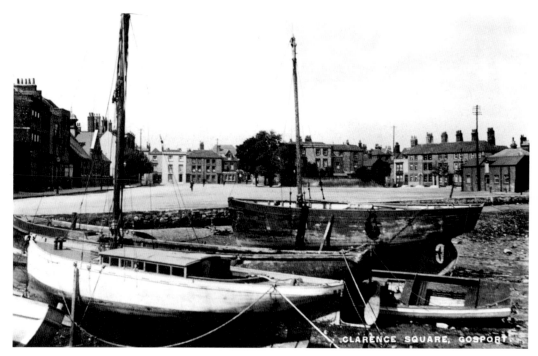

Clarence Square, as seen from the shoreline between the wars. Clarence Square School, visible on the left, was built in 1907 on the site of Burney's Academy, which closed in 1904.

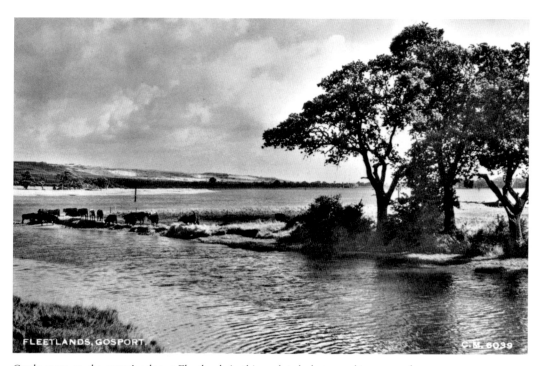

Cattle graze on the water's edge at Fleetlands in this undated photographic postcard.

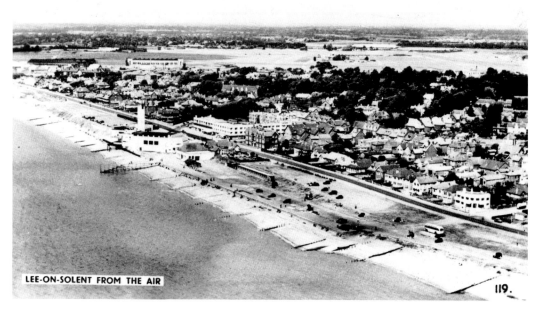

LEE-ON-SOLENT FROM THE AIR

119.

Lee-on-the-Solent seafront, *c.* 1950. The view of the Isle of Wight and the Solent was used to help promote Lee as a holiday resort from the 1880s.

BELLE VUE HOTEL

The Belle Vue Hotel, Marine Parade East, *c.* 1950. This popular hotel, boasting of 'the finest position overlooking the sea' expanded after the war under the proprietors Mrs Webb and Mrs Harmer. It closed in 2003 and was subsequently demolished.

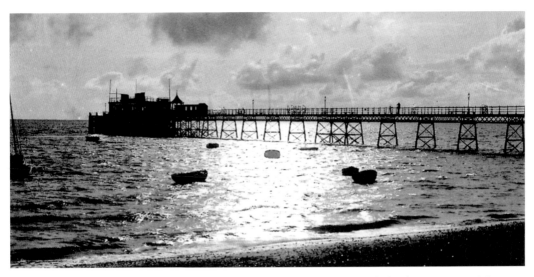

Lee-on-the-Solent Pier, 1920s. This romantic and tranquil view contrasts with the daytime view of the Solent, described in 1900: 'Brown-sailed barges are the artist's delight, and they are not lacking here. Fishing boats are plentiful, and a little fleet of oyster dredgers cruise to and fro, ironclads and mail steamers traverse the measured mile testing alike their speed and strength of their machinery. There goes one of the magnificent steamers of the North German Lloyd Company, a perfect floating palace, and yonder is one of the American liners, steaming past Calshot Castle, bound for Southampton. Torpedo boats, black and venomous looking, rush past at a high rate of speed, and racing yachts glide by in friendly and impartial contest.'

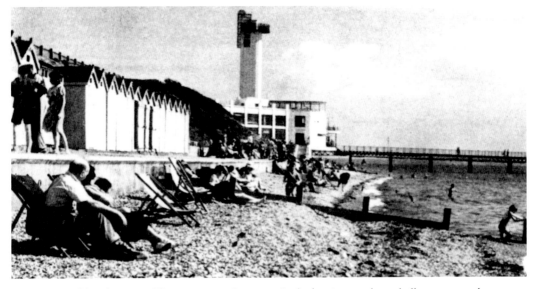

Lee Tower and beach, 1930s. The tower complex comprised of a cinema, dance hall, restaurant, bars and roof terrace. A lift took visitors to a 120ft-high platform with 'unrivalled views of the Solent and Channel'. Built by a local contractor, Mr Prestidge, it was described on its opening in 1935 as 'a monument of craftsmanship and energy to him for all time'. The pier was demolished in 1958, the tower in 1971.

Gosport Town

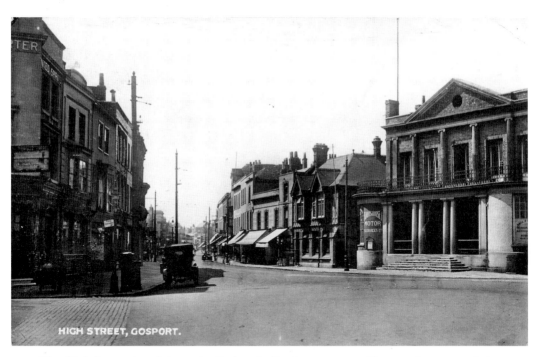

HIGH STREET, GOSPORT.

The High Street viewed from the Esplanade Gardens, *c.* 1931. Shop awnings covered the pavements protecting goods and customers from the rain and sun and created a more intimate atmosphere in which they could part with their money.

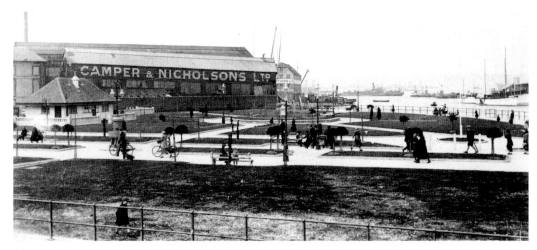

The Esplanade Gardens were constructed in the 1920s by the infilling of the old Hard area, a monumental task carried out by local labour under a government works programme. Widely known as the Ferry Gardens, they were renamed Royan Gardens in the 1970s and the Falklands Gardens in the 1980s.

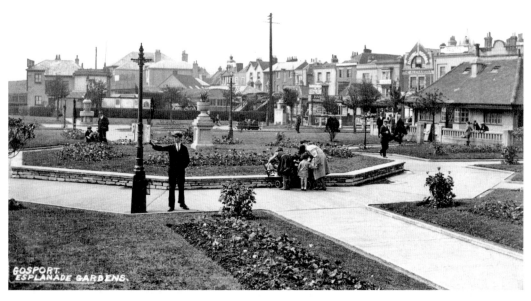

Admiral Gambier's old drinking fountain, erected in 1870, is visible on the left of this view of Esplanade Gardens from around 1930. Note the diversity of building styles fronting Beach Street, including the Alexandra Dining Rooms.

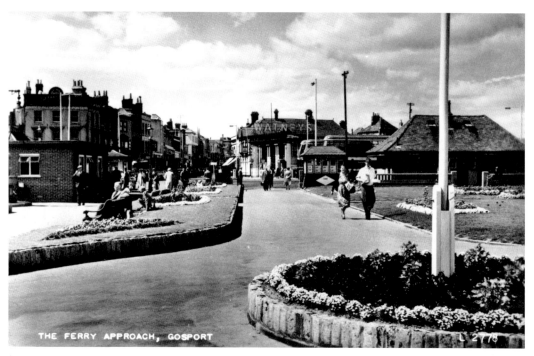

A post-war view showing the bombed Market House, behind which the Watneys sign of the Old Northumberland Arms is visible.

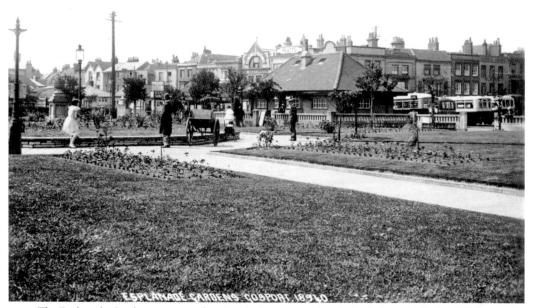

The Esplanade Gardens, *c.* 1930, showing the bus terminal and King's Arms in the High Street on the right.

High Street, 1930s. The Market House was occupied by the bus company Hants & Dorset, and is adorned with flags, presumably for a royal occasion. In the 1900s, the building accommodated the armoury and drill room of two companies of the 3rd Volunteer Battalion of the Hampshire Regiment.

A view of the High Street from the Market House, partially obscured by a flag. The King's Arms is on the right.

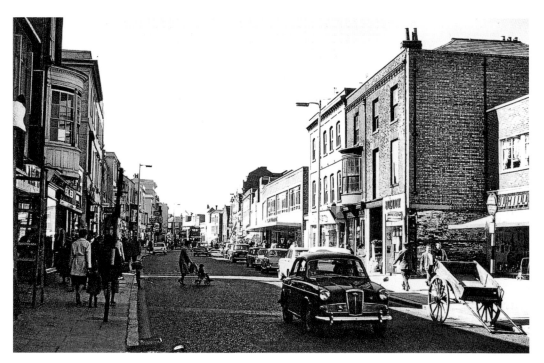

Gosport High Street in 1965.

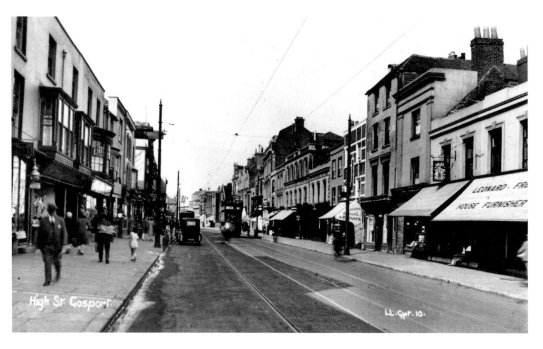

High Street, 1920s. The tram is passing the Home & Colonial Stores (on the northern side). Leonard Freake's house furnishing store is on the immediate right on the corner of Hobb's passage.

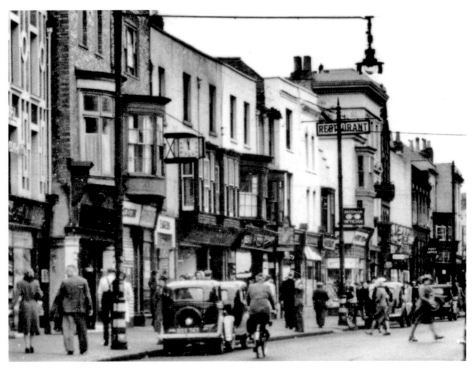

High Street in the 1930s. Just visible on the right is Bateman's opticians, on the corner of Bemister's Lane, and its neighbour Meotti's Swiss Café and Restaurant, which was the headquarters of the local Rotary Club. The Bateman's chain was taken over by Vision Express in 2008.

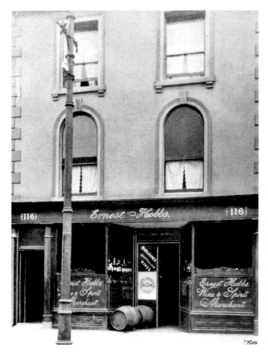

Ernest Hobbs' wine and spirit merchants, 116 High Street. In the thirsty town of Gosport, the Hobbs family of Gosport astutely invested in drink. Ernest's father, William, was a director of the local waterworks company and the family also founded the Dolphin Brewery in North Street and later bought the Stoke Brewery in Stoke Road. When William died in 1900 he left the equivalent of £16 million (using average earnings as an indicator).

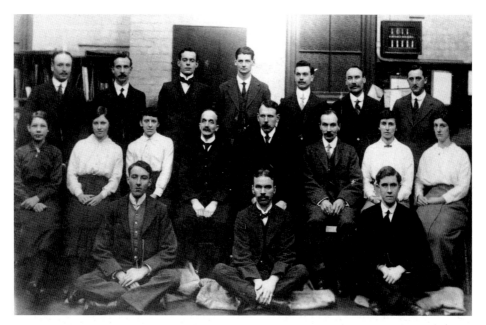

Post Office staff, *c.* 1916. Sitting in the centre is the recently appointed Mr John Barlow. During the First World War, the three daily deliveries were made with the help of female post-persons for the first time.

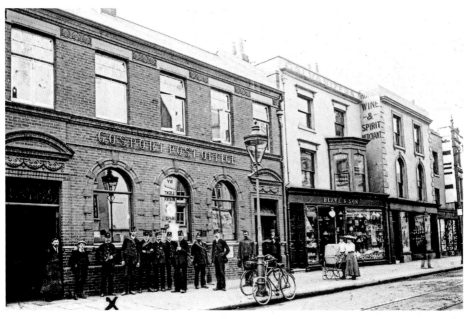

The High Street post office and postmen, *c.* 1910. At this time, local households had three deliveries a day, and one on Sunday. Blake's (*right*) traded as an ironmonger from the 1860s, having taken over the business from Jane and Caroline Darby. By the early 1900s, Blake & Son had diversified and set up the Algicide and Anti-Fouling Company, run from the same premises. On the right is Ernest Hobbs' wine merchant's.

High Street, winter 1985. Visible here are the Gosport bookshop (which closed in 2007) and the publicly owned gas board premises (privatised in 1986 and subsequently closed).

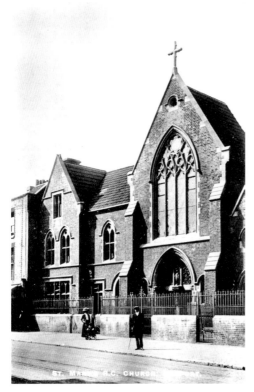

St Mary's Roman Catholic Church, c. 1910. A church was built on this site and completed in 1878, replacing a chapel that had stood in South Cross Street since around 1750. In 1900, the frontage was renewed and a new presbytery built.

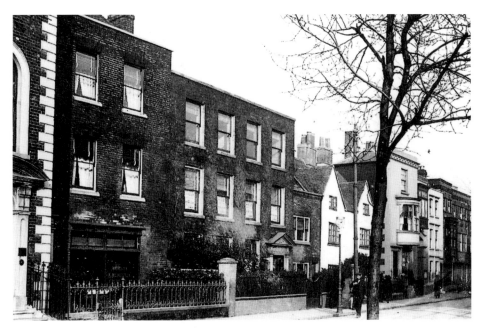

High Street, 1920s. This rare view shows the diversity of houses that existed before redevelopment. On the left is No. 5 (on the site now occupied by Argos), which was built in around 1670, at which time it overlooked a meadow. In 1700, it was purchased and served as a manse for the minister of the Independent Chapel. In 1777, David Bogue came to the town and set up an academy here to train men for the ministry, many of whom were notable in the spreading of Christianity throughout the world. By the First World War, the house was the office of the Weights and Measures inspector, and later the local branch of the Ministry of Health and Pensions. The house was demolished in the 1960s.

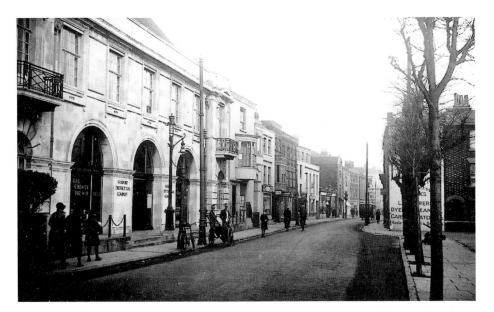

The Gosport District Gas Company premises were built in around 1917, following demolition of the buildings seen above.

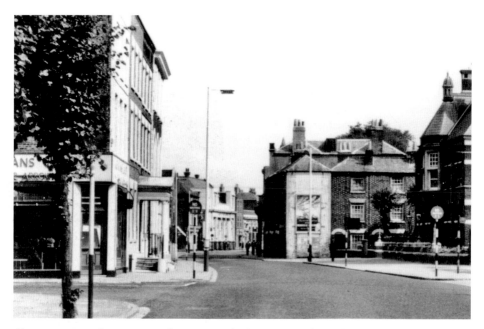

Chapman's Laundry, seen on the corner of Clarence Road South, was one of over forty Chapman's branches in the 1940s. Elizabeth Chapman started the business in the back room of her home in Hambrook Street, Southsea, in 1887, using a dolly tub, hand wringer, flat iron and plenty of elbow grease.

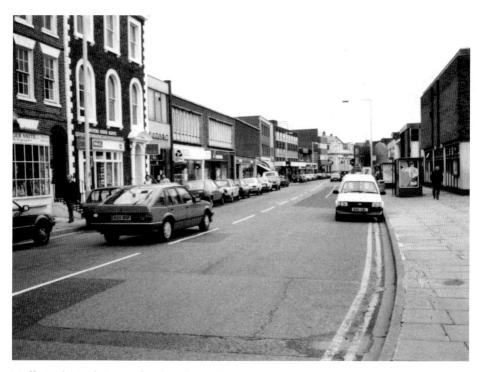

Traffic in the High Street, shortly before pedestrianisation was introduced in 1988.

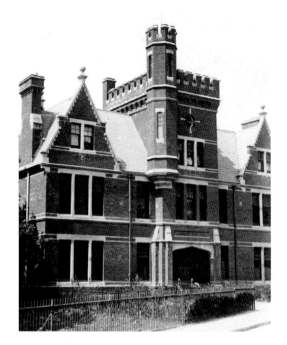

The Connaught Drill was built at what was then the top of South Street in 1902, for two companies of the 3rd Volunteer Battalion, Hampshire Regiment. As well as a drill hall, the building housed an armoury, officer and orderly rooms, men's recreation room and non-commissioned officers' club.

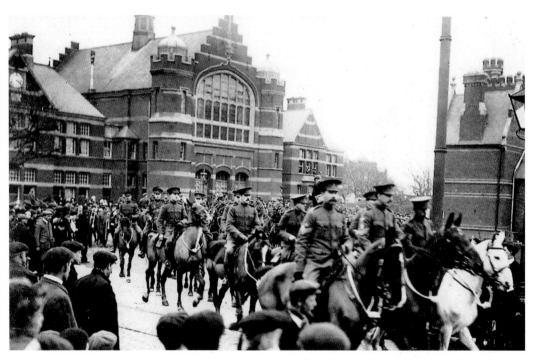

Gosport Territorials leaving the Connaught Drill Hall (*right*), which stood on the site of the main Gosport Library. The Thorngate Hall (*centre*), built in 1885 to a design described as 'the Flemish Gothic style', had seating for 650 people and was a memorial to wealthy local merchant, William Thorngate. The building on the left served as the offices of Gosport Borough Council while those on the right of the hall were used by the Thorngate trustees and local societies.

Gosport Library, c. 1901. Mean-spirited, wealthy ratepayers had to be worn down before the Public Libraries Act could be adopted by the town. A second-hand wooden shack was erected in 1889 behind the Thorngate Hall at a cost of £25, but it was inadequate from the outset. The Art Nouveau style Library and Technical School (latterly Gosport County Grammar School) was opened in 1901.

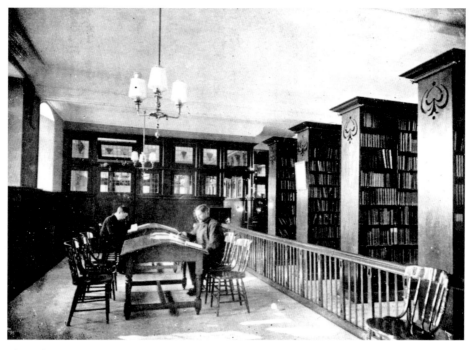

The Reference Library, c. 1901. Visitors had to consult a catalogue and ask for a specific book, rather than pick it off the shelf themselves.

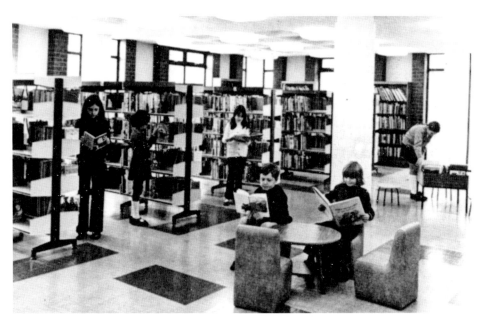

Children's Library, c. 1973. A new Gosport Library, which took two years to build, was opened in October 1973 at a cost of £240,000. The library opened with a book stock of 92,000.

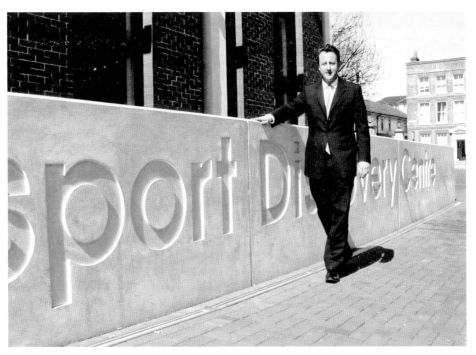

David Cameron at Gosport Discovery Centre, April 2006. The library was rebranded, refurbished and reopened in 2005, with 27,000 fewer books than it had when it opened in 1973. David Cameron arrived in Gosport by helicopter sporting a green tie and gave a speech in the Discovery Centre expressing his concern about the environment.

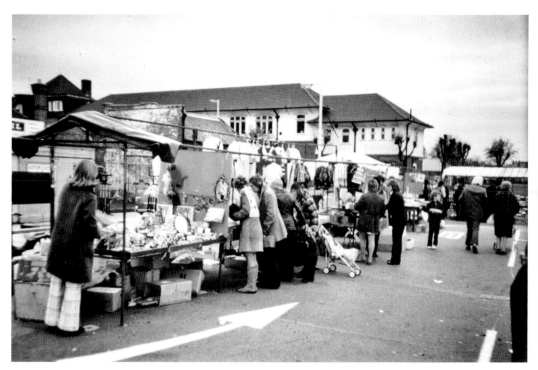

Gosport Market, 1970s. Before pedestrianisation of the High Street, the market was held on this site off Clarence Road South.

Driving Test Centre, Walpole Road, 1988. Formerly a drill hall for the Territoral Army, this building was demolished to make way for the Safeway store, latterly Morrisons.

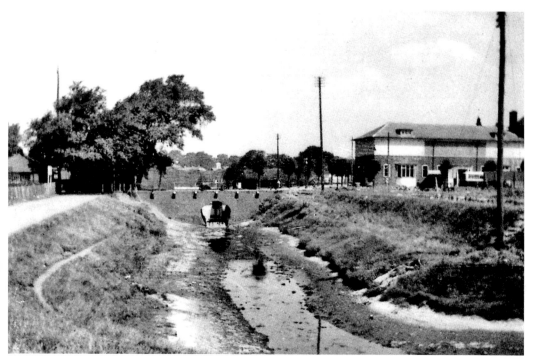

The moat under Walpole Road. The ramparts were constructed from earth excavated from the moat and refilled from the 1890s onwards, though this section survived well into the twentieth century.

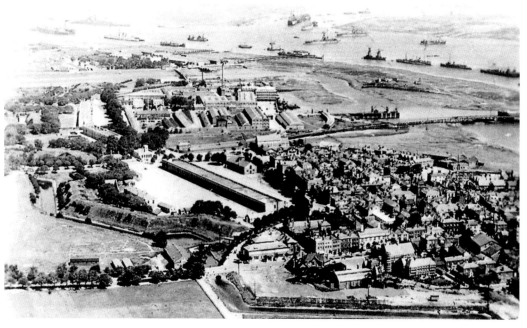

Gosport Town remains enclosed by the moat and ramparts in this aerial view showing the High Street, New Barracks (latterly St George Barracks), Royal Clarence Victualling Yard and Priddy's Hard in the distance.

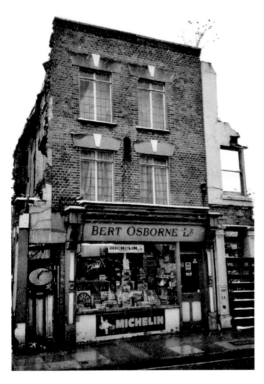

Bert Osborne's survived in North Cross Street until the 1980s.

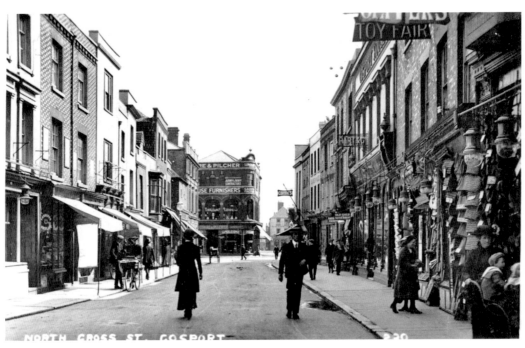

North Cross Street, c. 1915, looking towards the High Street. The Blacksmith's Arms is visible in South Street, beyond Hoare & Pilcher's house furnishers on the corner of South Cross Street.

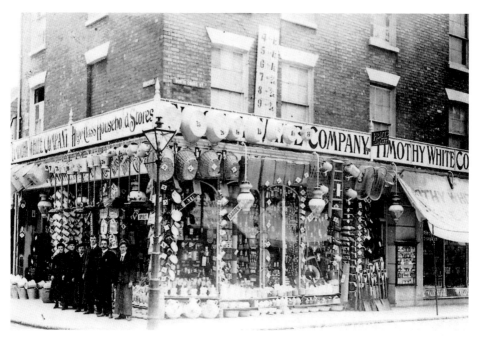

Timothy White's, North Cross Street, *c.* 1910. Mr White set up his first chemist shop in Portsmouth in 1848 and by the 1890s his company ran one of largest chains of drugstores in the country. By the time this photograph was taken the company had diversified into household goods. By the 1930s, Timothy White's was trading from 127 High Street between Ashby Place and South Cross Street.

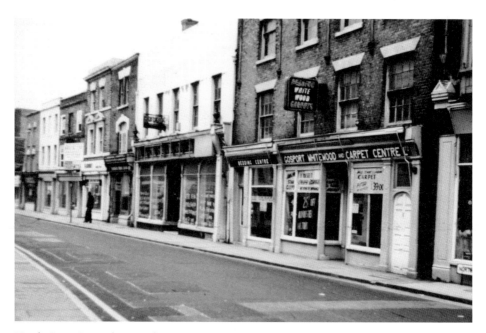

North Cross Street shops in the 1970s.

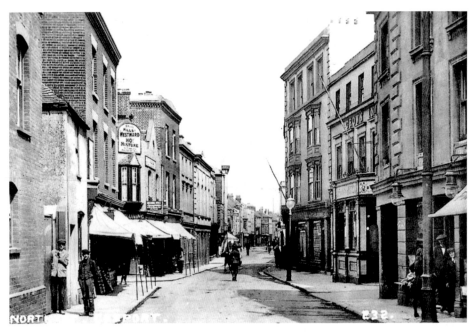

North Street, looking east, on the eve of the First World War. North Street ran parallel with the High Street from the Green to Clarence Road. Gluning's tobacconist shop is on the corner of Kings Street (first left).

North Street in the 1970s. Gluning's is now an electrical repair shop, and the Crown Inn provides another bearing. Gosport Literary Institute held meetings, lectures and musical entertainments in the Crown in the 1850s.

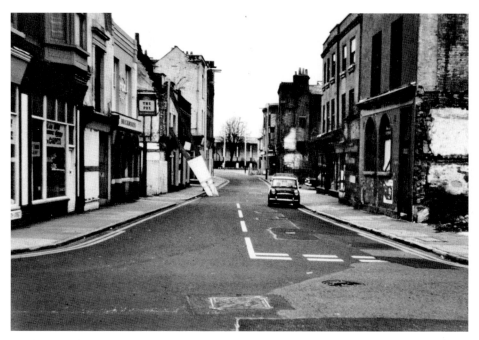

North Street, looking west towards St George Barracks in the 1970s. Upfield's linen and drapery business stood four doors further up from the Fox pub.

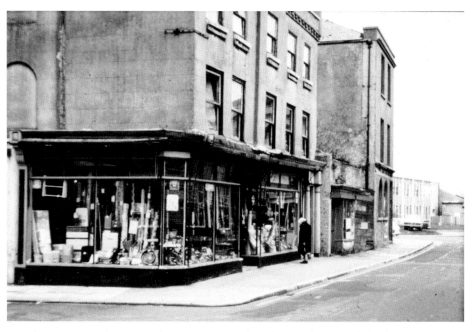

Murphy's store stood opposite the Fox. Henry and Emily Murphy opened the shop in 1932 and rapidly gained a reputation for stocking anything of use around the home, including the kitchen sink.

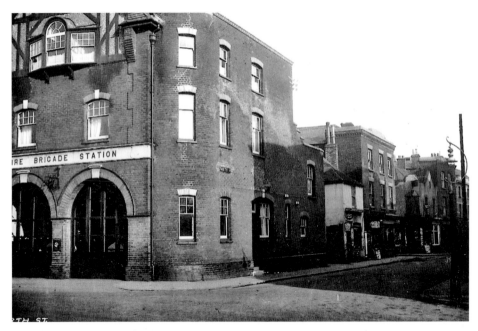

North Street seen from Clarence Road, *c.* 1925 (taken from the opposite side of the road to the previous photograph), showing part of the old fire station.

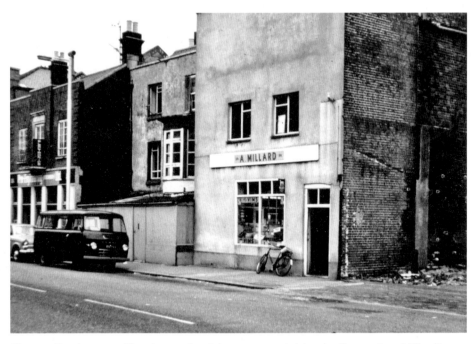

Clarence Road, 1970s. The site on the right was occupied by the fire station. Millard's was established as a 'corn chandler' in around 1910, but later diversified. Fred Dade ran a fish shop in the premises on the left between the wars.

Stoke Road Area

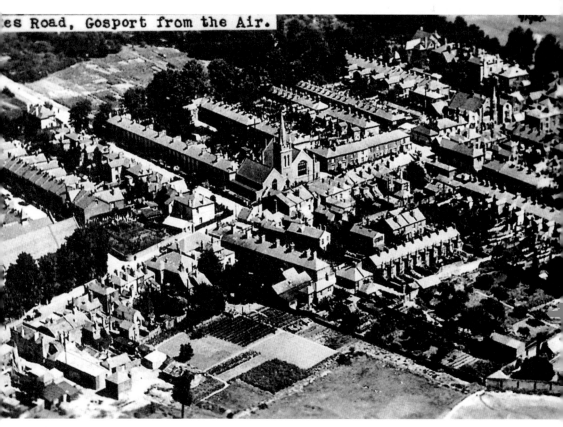

es Road, Gosport from the Air.

Stoke Road, seen here between the wars. Peel Road, Oak Street and Holly Street are cul-de-sacs, blocked by the boundary wall of the Grove. In the middle of the eighteenth century, the alley beside the Royal Arms led to Chester Place where John Galpin, Gosport's last rope-maker, had his works. On the left a row of fine elm trees that stretched along a large section of Stoke Road is visible.

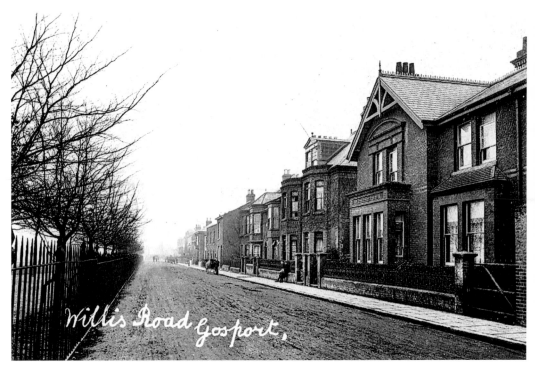

Willis Road faced the Horsefield until the 1920s, when the ground was levelled, laid out and renamed Walpole Park.

Prince of Wales Road, *c.* 1927, with the entrance to the Grove Estate at the far end.

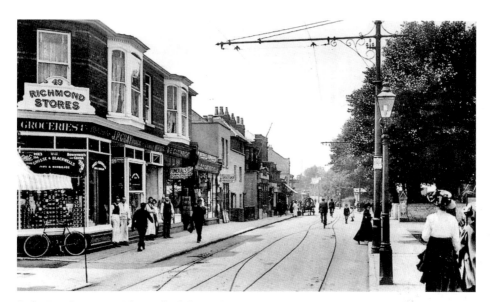

Stoke Road, *c.* 1912. The staff of the Richmond Stores pose for the photographer. Next door is Ben Cartwright's undertaking and house-furnishing business. Note the elm trees lining Stoke Road, survivors of the time when it was a deeply rutted cart track with fields and orchards on both sides.

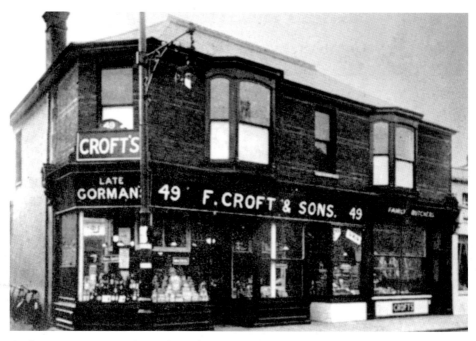

Croft's stores, *c.* 1937. The Richmond Stores premises appear to have changed hands twice between the wars. Gorman's General Supply Stores sold homemade bread, 'finest colonial meat' and wines and spirits, and marketed itself to the yachting community as ideal for the supply of provisions. F. Croft & Son has expanded and is running a butcher's shop in the former undertaker's next door. This was one of four branches of Croft's Hampshire chain.

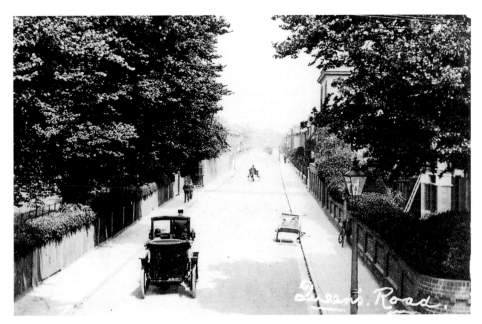

Queens Road was opened in 1857 and the houses on the right fronted a cow pasture called Hobb's Field – named after the local brewing family – which extended as far as Elmhurst Road. The southern end of Elmhurst Road was called Hobb's Road, at the end of which was their brewery, mineral water company and residence (see page 24).

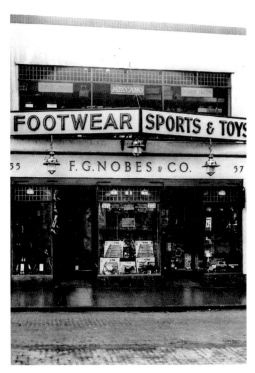

F. G. Nobes & Co. was solely a shoe retailer when it was first established at 55–57 Stoke Road, but diversified into sports equipment and toys by the 1930s. Meccano and Hornby train sets are advertised in the window.

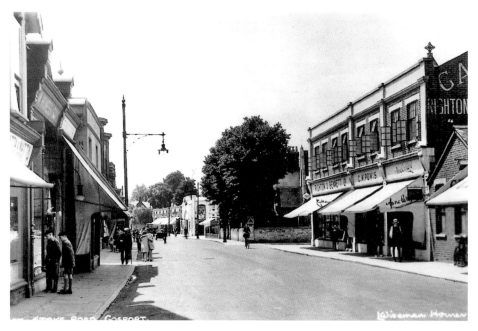

Stoke Road, *c.* 1933. Originally a roller skating rink, the Olympic Cinema is visible in the distance but would soon close. On the right is Anne Crosland's ladieswear shop, Cecil Powys' tailoring business and Righton & Bennet, automotive engineers, on 'motor corner'. Something in Honess & Sons' dyer's and cleaner's shop window has caught the eye of the schoolboys on the left.

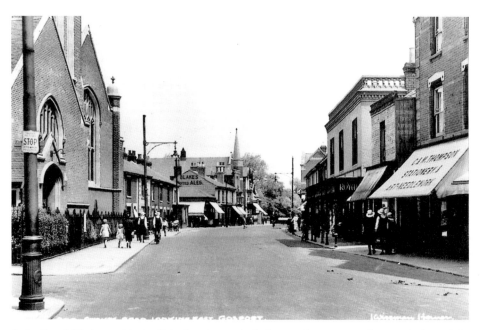

Stoke Road Wesleyan (Methodist) church was built in 1910/11 to serve the population of the rapidly expanding Newtown. The tower survived a serious fire in 1989.

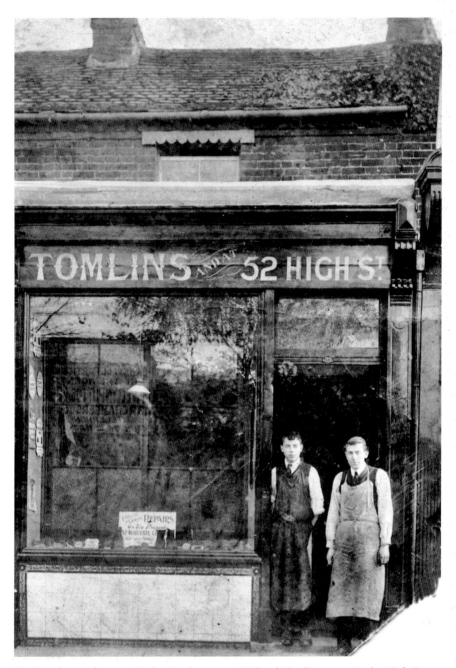

Tomlin's bootmakers, 99 Stoke Road, c. 1911. Richard Tomlin set up in the High Street in around 1890 and, by 1911, had opened this branch and another in Gladys Avenue, Portsmouth. He was a pioneer in employing disabled workers in his workshops. On the left is Leslie Tomlin and on the right, Reginald Stock, who married into the family and by the 1930s was running the business.

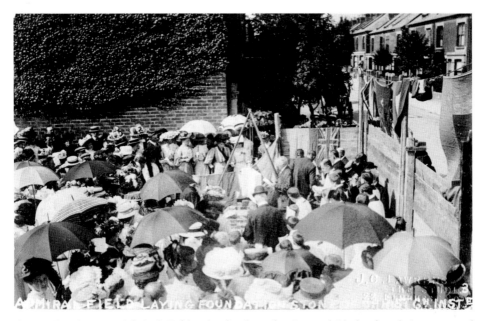

Avenue Road, 1908. Admiral Field, who lived at the Grove, laid the foundation stone of Christchurch Institute, which, as well as running Sunday school and church clubs, served as a venue for community events. Proceeds from the famous Grove pageants helped to build and maintain it.

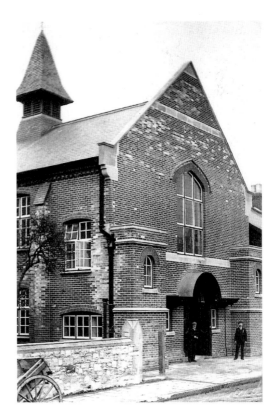

Christ Church Institute, *c.* 1908, shortly after completion. It was demolished a hundred years later and replaced by flats and a new parish centre.

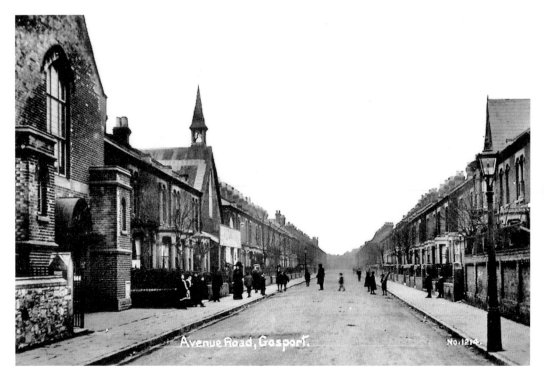

Avenue Road, *c.* 1910. The Baptist 'Tin' Tabernacle, on the left, was actually made of timber and galvanised iron. This was replaced by the Baptist church in Stoke Road in 1910, and the 'Tin Tabernacle' was sold and used as a cheap cinema, the Picturedrome, until 1916 when it burnt down. Opposite, Nos 2 and 4 were occupied by the Soldiers' and Sailors' Institute.

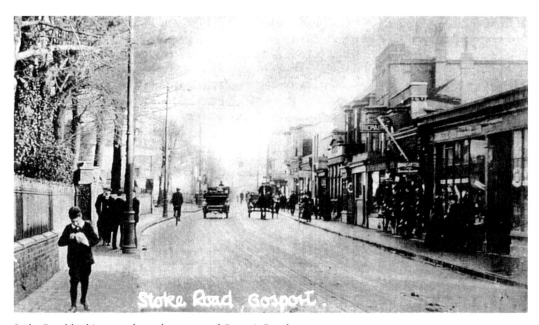

Stoke Road looking east from the corner of Queen's Road, *c.* 1910.

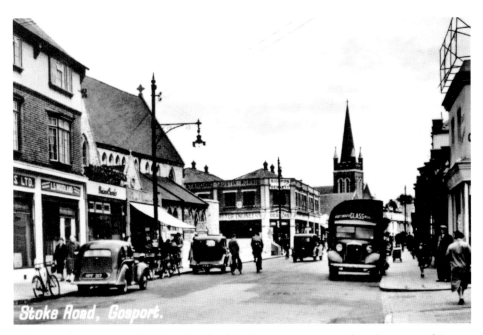

Stoke Road, *c.* 1950. On the left is Woodland & Co., estate agents, and on the corner of Avenue Road is another view of Righton & Bennet's automotive engineers.

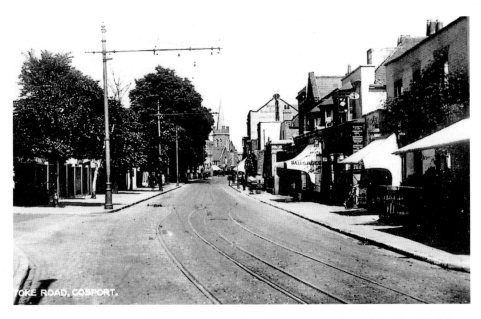

Elmhurst Road is on the left of this view, taken before the erection of Portland Buildings, which included Arthur Bull's china, hardware, toy and stationery stores. Herbert Pyle's bakery shop stood on the corner of Shaftesbury Road on the right. William Churcher's monumental and ornamental masonry showroom, which opened in 1867, is also visible just past Pearman's butcher's advertising sausages on its awning.

Stoke Road, looking west, *c.* 1965. The site on the left was occupied by a large, detached residence, Stoke House, Mr Groom's orchard and nurseries, and then the Forum Cinema, which opened in 1939 and closed around twenty years later. Aldridge & Riddle's Garage is seen here, before Waitrose supermarket was built on the site.

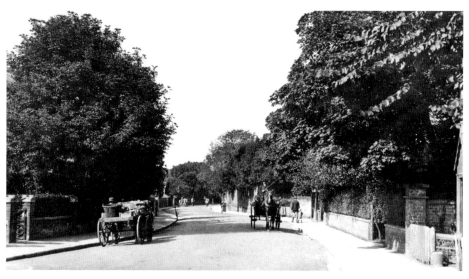

Bury Road, *c.* 1905. Mature trees conceal the residences of the well-to-do. Gosport High School was established in Bury Road in 1888. It was one of the few schools to remain open during the war and its air-raid shelter was later used as bike sheds. The uniform was a blue blazer with white, vertical stripes, cap and tie, all available from Rowe's, the upmarket High Street outfitters. The school closed in 1972.

School and Church

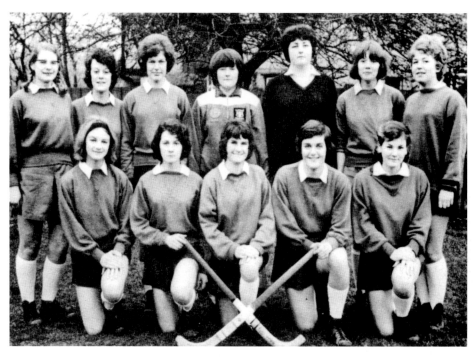

Gosport County Grammar School, Hockey First XI, 1963–64. Standing: Brumpton, Mitchell, Hawkins, Dimmer, Kelly, Cordory, Lewis. Kneeling: Grimble, Jerrard, Stayte, Hodges, Ayling.

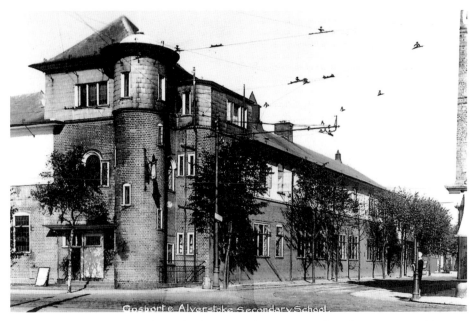

Gosport and Alverstoke Secondary School, *c.* 1915. The Gosport Technical Institute opened in 1901 after the accommodation at Star Chambers in the High Street became inadequate to meet demand. It changed its name several times, but is best remembered as Gosport County Grammar School.

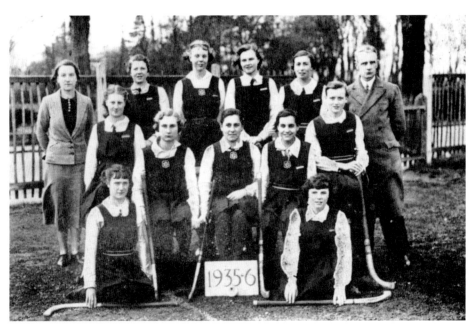

Gosport County Grammar School, Hockey First XI, 1935–36. Standing: Betty Cheer, Dorothy Nuse, Violet Acock, Dora Woodford. Sitting: Betty Milborn, Beryl Cross (captain), Dorothy Graham, Rosalind Elgie. Kneeling: Doris Oldridge, Olivia Cooper. This formidable team lost only one match that season.

Clarence Square Council School for boys opened in 1907. Average attendance in the first year was 300 pupils, kept in line by headmaster William Coalbran.

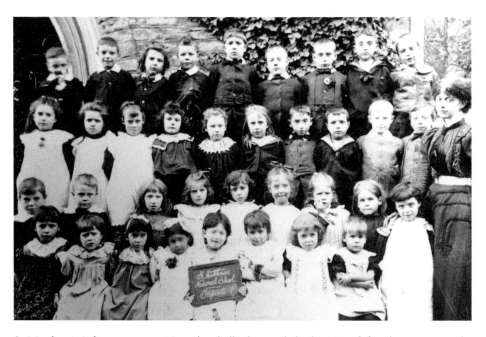

St Matthew's infants, *c.* 1900. Note the chalk slate and the boy (*top left*) who appears to be exploring his nostril with his finger.

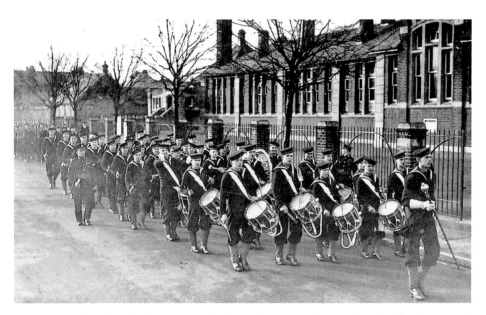

Grove Road School was built in 1909 and enlarged two years later. At the time this photograph was taken the headmaster was Frank Small who had previously taught at Clarence Square School. St Vincent's band is seen here, the drummers setting the pace.

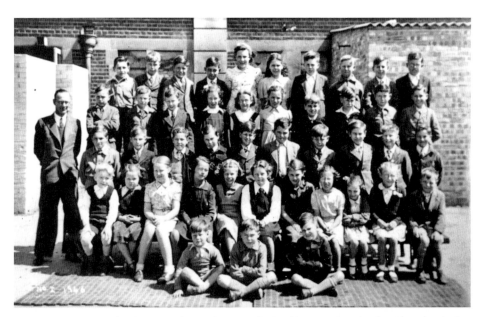

Grove Road Junior School, 1946. The teacher, Mr Blackwell, is seen here back at the school after demobilisation. Back row: Ralph Collins, Donald Meakin, John Keeping, Brian Vickers, Ann Pitcher, –?– , Michael Savage, Arthur Ring, Len Seabrook, Gordon Jolly Next row: Taffy Lewis, Robin Cherry, David Orpin, –?– , Jean Rudland, Keith Gorman, –?– , Bennet, Barry McCann, Next row: Raymond Oliver, John Clements, –?– , –?– , –?– , Gerald Banks, Lewis Daniels, Jim Hensman, –?– , David Powell. Smaller children were the younger brothers and sisters of class pupils who were included to save parents buying two photographs at a time of post-war austerity.

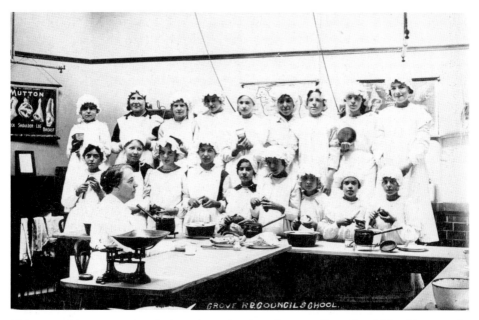

Girls pose with potato peelers during a domestic science lesson at Grove Road School between the wars. One distinguished old boy of the school was the professional soccer player Stan Cribb, who played for Saints, QPR and Cardiff, and later was a founder and manager of Gosport Borough.

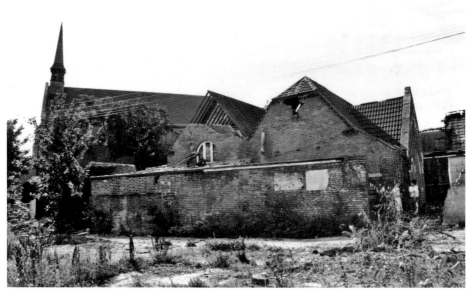

St John's School was built in 1830 and expanded through the nineteenth century as Forton grew. The school adopted the Free Education Act in 1893, at which time the managers announced, against the spirit of the act, that they would be charging for books and slates at the rate of a penny a month for infants and two pence a month for boys and girls in their junior schools. The school closed after 1958 when the pupils moved to the more spacious Grove Road. The old buildings were used by a tyre dealer for some years, but are seen here, derelict, in the 1980s.

Ambleside School in Crescent Road stood on the corner of St Mark's Road, opposite the Anglesey Hotel. In 1939 the school was described as a boarding and day school for 'the daughters of army, navy and professional men', though it did also accept boys younger than eleven.

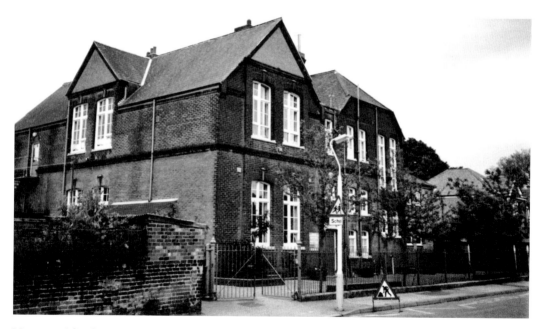

Newtown School in Grove Avenue was built to replace a school room that had been set up in Joseph Street in 1853 and proved inadequate to cope with the growing population. The building was demolished and the school relocated to Queens Road in 1998.

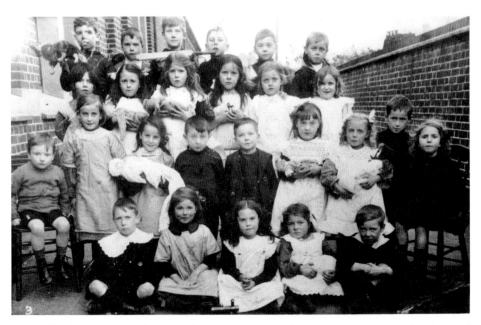

Leesland Infants, *c.* 1910. Some teachers evidently permitted a favourite toy to be displayed during class photographs, producing a more interesting and less formal portrait. Clutching a teddy bear, second row down, second from left, is Doris Amelia Tollervey (*née* Bailey).

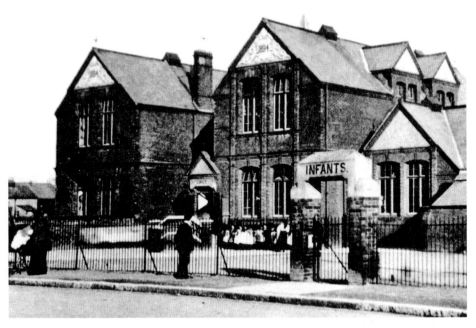

Leesland Elementary School, *c.* 1908. Built at a cost of £6,000, Leesland opened in 1894, with space for 240 boys, 240 girls and 270 infants. The first headmaster was Mr Taylor, the headmistress Miss Kate Handy and the infants' headmistress, Miss Gale. This Church of England school is currently attempting to raise money from companies by selling advertising space in the school's hall, library and other areas.

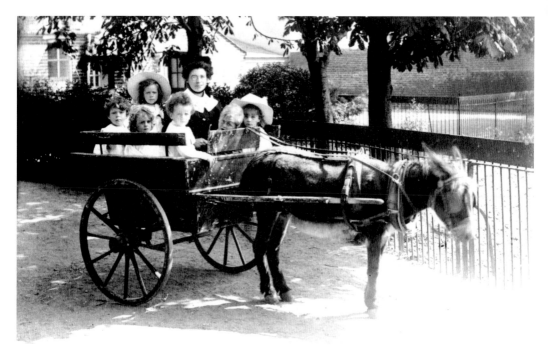

A pony and trap at Alverstoke Children's Home and Orphanage, c. 1909. A monocled matron ensures children get some fresh air.

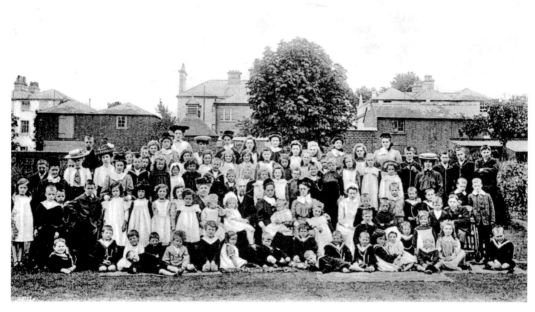

In 1887, a Mr Diggle of Alverstoke donated some land to Thomas Stephenson, a Wesleyan minister based in Lambeth, to provide accommodation for slum children who were 'ragged, shoeless, filthy, their faces pinched with hunger...'.By 1900, the home had added buildings and a farm at Gomer, the produce of which, along with the fruit trees at Alverstoke, made it self-sufficient.

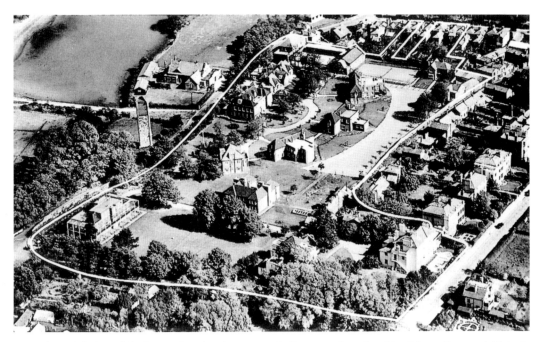

An aerial view of the home, showing the purpose-built sanatorium, Sunshine House (*bottom left*), built in the early 1930s following a nationwide appeal for funds.

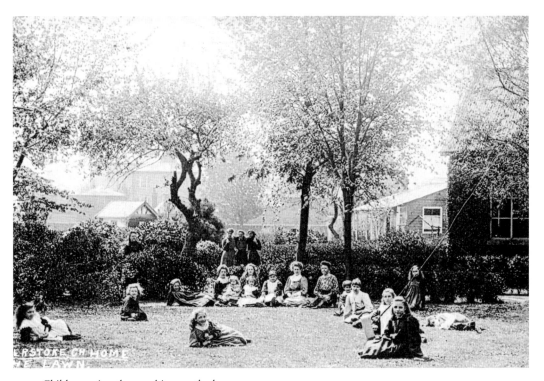

Children enjoy the sunshine on the lawn, *c.* 1920.

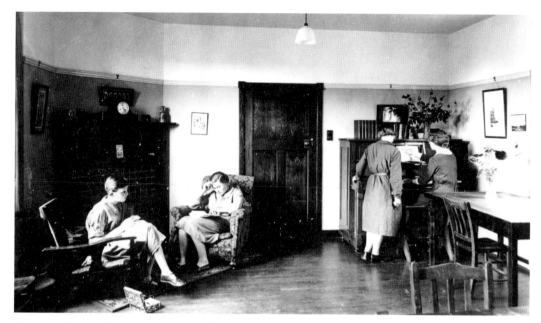

Stephenson House interior, c. 1936. Included on this fund-raising postcard are Nancy Little and Molly Pinner.

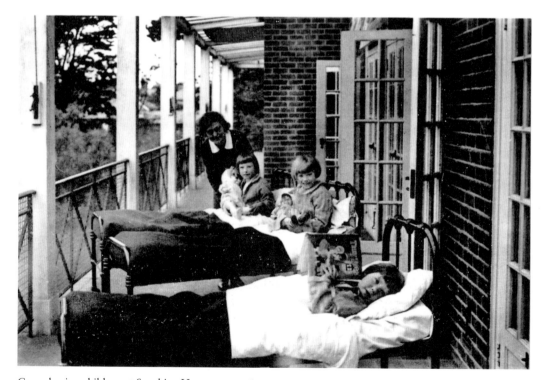

Convalescing children at Sunshine House, c. 1936.

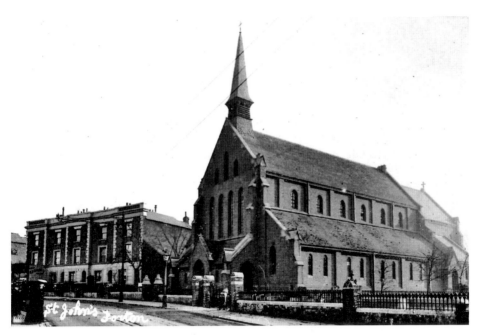

St John's church, Forton. The first St John's was consecrated in 1831 and, by the 1870s, was serving the Royal Marine Light Infantry from Forton Barracks. Work began on building on the new church in 1891 and was finally completed in 1906.

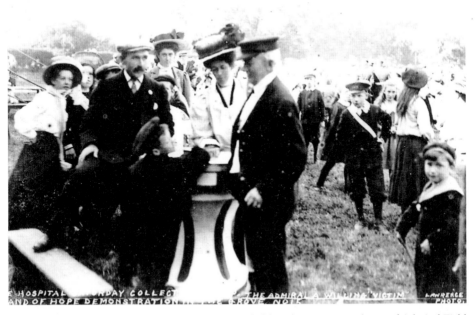

A Band of Hope demonstration at a charity event held in the Grove, residence of Admiral Field (*centre*). The Band of Hope was a temperance movement aimed at persuading working-class children to take a pledge of total abstinence by highlighting the evils of drink.

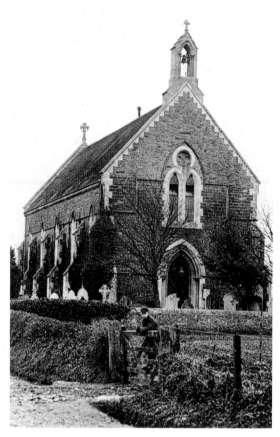

St Thomas's church was built in the village of Elson in 1845. By 1870 the village had grown to 287 houses, with a population of 1,530.

St Thomas's church room, Elson Road, *c.* 1935.

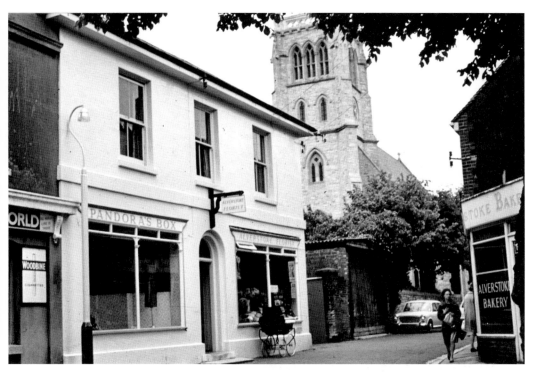

St Mary's church, from Church Road, 1965. The Woodbine advertisement on the left is mounted on the old Five Bells pub, which closed in 1922. Note the vintage perambulator parked outside Alverstoke Florist.

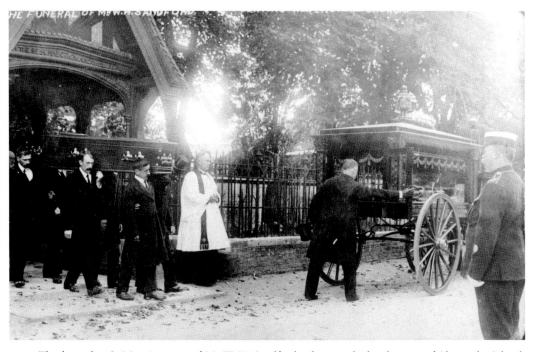

The funeral at St Mary's, 1914, of Mr W. H. Sandford, who was the headmaster of Alverstoke School.

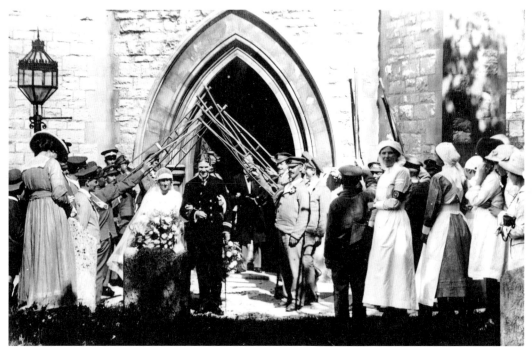

St Mary's church, Alverstoke, 1918. Wounded soldiers form an arch with their crutches at this wartime wedding.

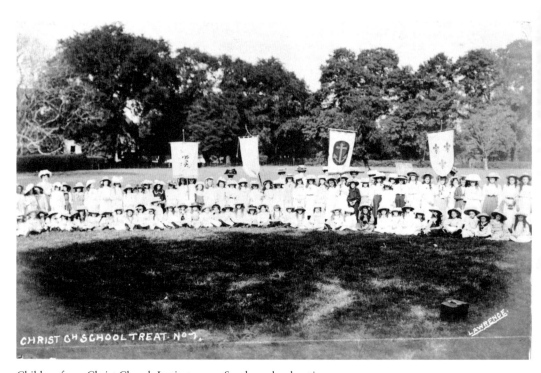

Children from Christ Church Institute on a Sunday school outing, *c.* 1910.

Leisure and Pleasure

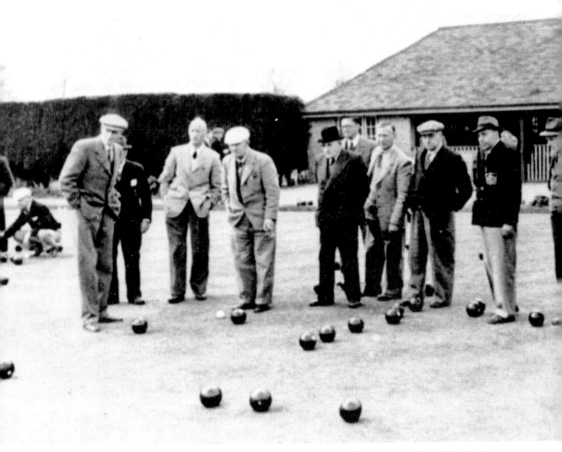

The bowling green, Anglesey Gardens, *c.* 1956. Players who favoured the English Bowling Association game with narrow bias woods were welcome at this Borough facility, which boasted a Cumberland turf green, according to the Gosport guide.

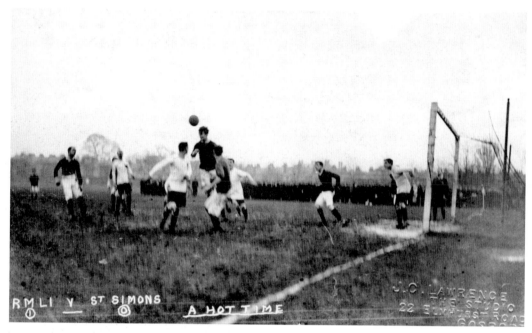

A victory for the Royal Marine Light Infantry soccer team at Forton, *c.* 1909.

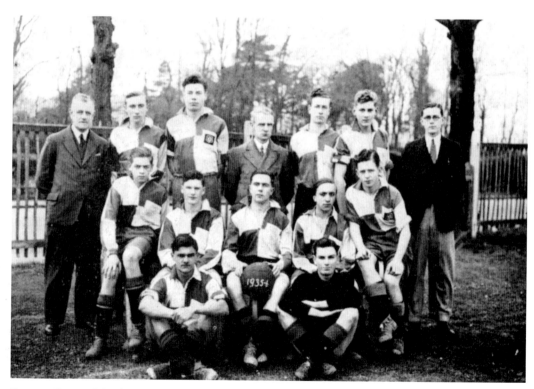

Gosport County School First XI, 1935–36. Back row: Carswell, Bell, Wearn, Jacobs. Middle: Gibbs, Walker, Janssens (captain), Philbrick, Nicholson. Front: March and Leech.

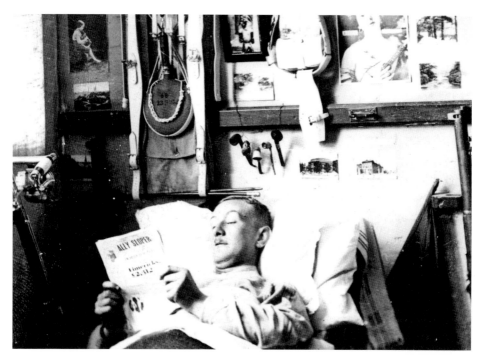

A soldier in a local barracks relaxes with a magazine before the First World War, with his pipes within easy reach in a makeshift wire rack and his bicycle parked beside his bunk. Ally Sloper, whose name appears in the magazine, was one of the earliest comic strip characters.

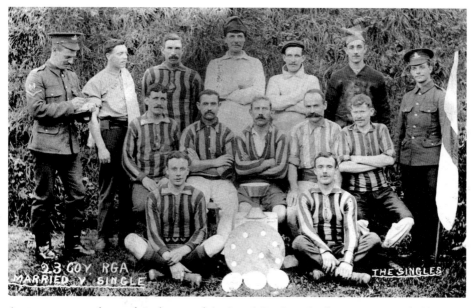

A soccer team made up of single men of the Royal Garrison Artillery, *c.* 1909, probably based at Fort Grange.

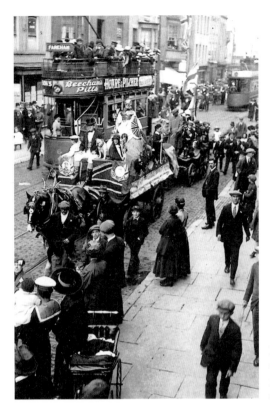

Britannia travels along the High Street
on a float driven by John Bull, the
personification of Great Britain, in the
coronation celebrations of 1911.

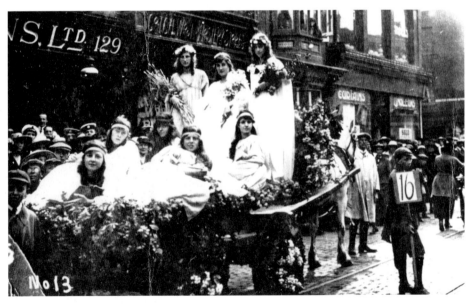

Gosport Carnival float in the High Street, c. 1918. South Cross Street is visible on the right,
with Hoare & Pilcher, house furnishers, on the near corner. The boy on the left of the float
with spectacles was suffering from tuberculosis. Poverty was such that it was not unusual to see
shoeless children scavenging scraps in the street.

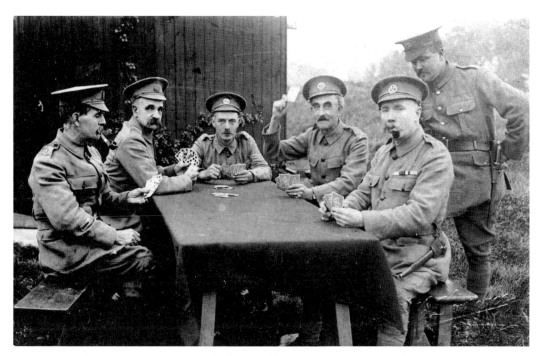

Gosport Volunteers, *c.* 1914. Walter Richardson, landlord of the Robin Hood pub (see page 128), shows his hand.

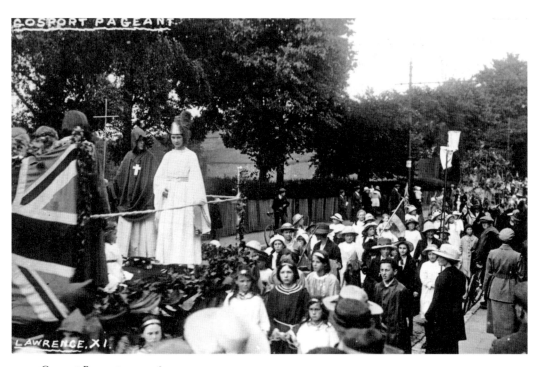

Gosport Pageant, *c.* 1916.

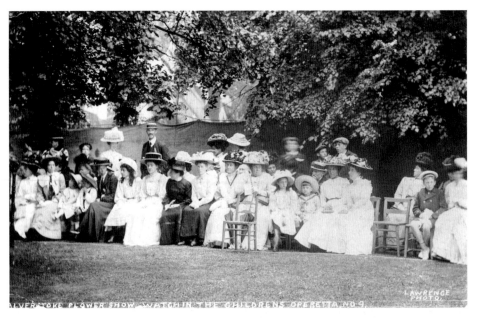

Alverstoke Flower Show, *c.* 1909. An unmistakably Edwardian audience is entertained by the children's operetta.

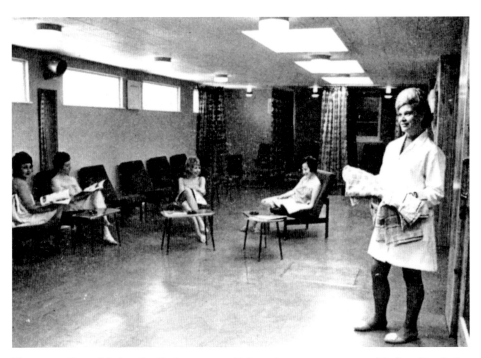

The sauna, Central Swimming Baths, *c.* 1975. 'It is no longer necessary to visit Scandinavia for a sauna bath,' reported the *Gosport Official Guide*, which helpfully pointed out that there was one in South Street.

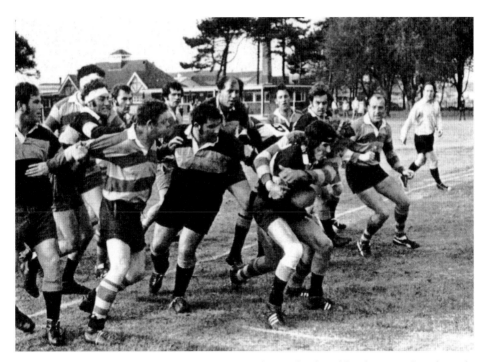

Rugby at Gosport Park in the 1970s. Gosport Park was developed by the council in the early 1890s, having previously been an expanse of furze land called Ewer Common, which was a regular pitch for gypsies.

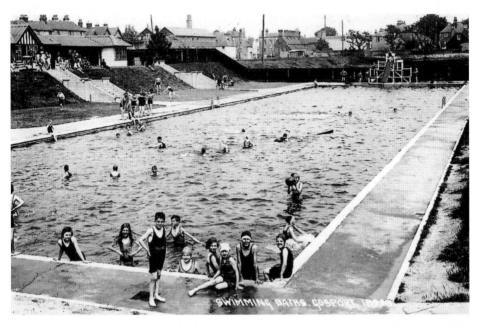

The open-air, sea-water swimming baths opened in 1924. By the 1950s, one could bath at night under new flood-lighting. Flux's laundry chimney (formerly Haslar Street Brewery) is visible in the distance.

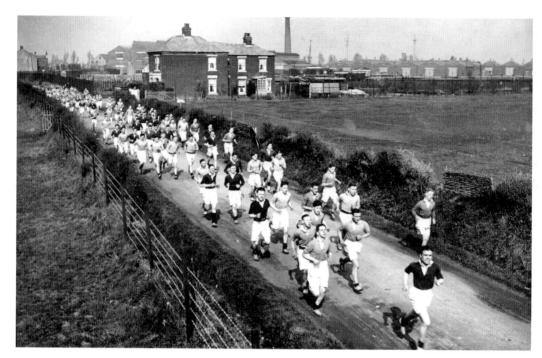

Men of HMS *Fisgard* – the engine artificer training ship at Hardway – in a cross-country race in 1931. Priddy's Hard is visible in the background.

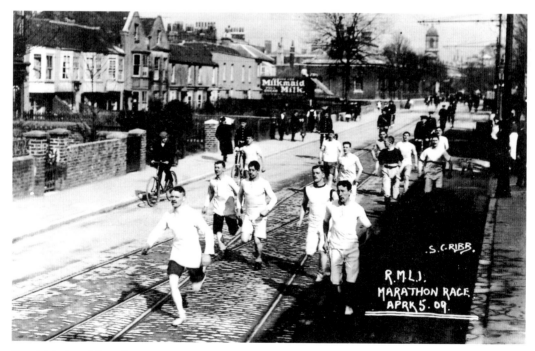

Royal Marine Light Infantrymen start a marathon from Forton Barracks at a brisk pace in Forton Road in 1909.

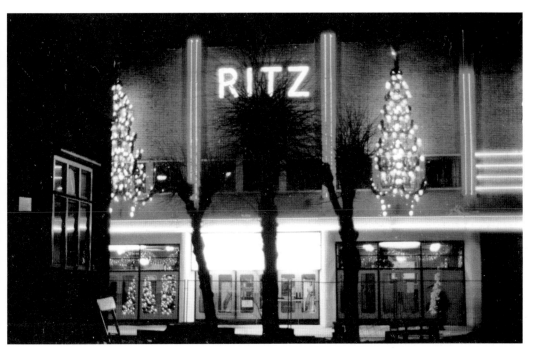

Christmas at the Ritz, 1991, a place that entertained all generations and brought the High Street to life.

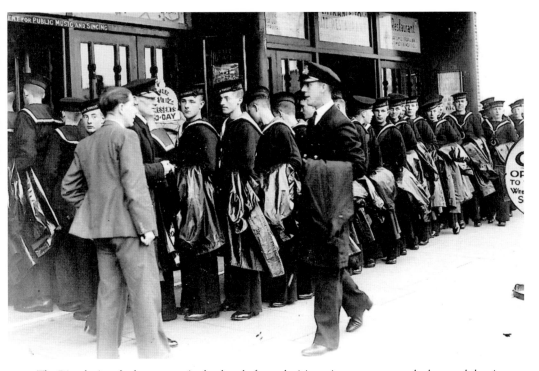

The Ritz during the late 1930s; in the days before television, cinema queues snaked around the cinema. The entertainment here clearly has appeal for St Vincent boys.

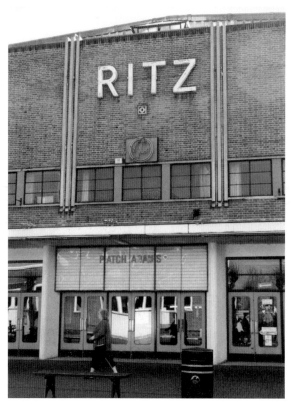

The Ritz in 1998, a year before its final closure.

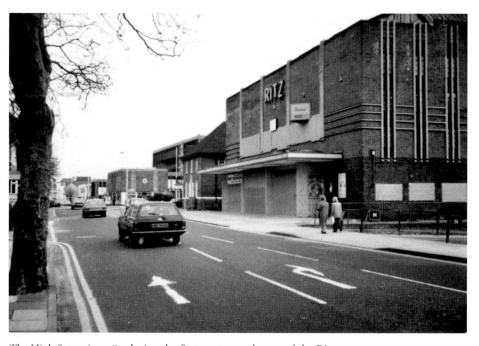

The High Street in 1984 during the first post-war closure of the Ritz.

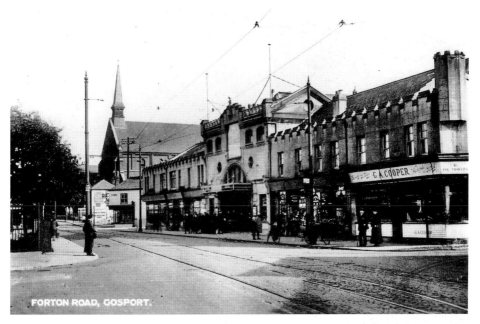

The Criterion cinema, Forton Road, opened in 1912 on the site of the old Admiralty Waterworks. The castellated building included shops; neighbouring the theatre were Winifred Lyne's tobacconist shop and Alfred Ditch's sweetshop. George Cooper's butcher's shop is on the corner of Lees Lane North, one of three branches in Gosport in the 1930s.

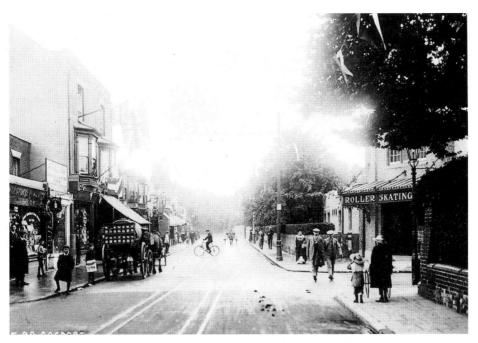

The Roller Skating rink on the corner of Queens Road, *c.* 1912. The rink closed and, by 1914, was converted into a cinema, the Olympia.

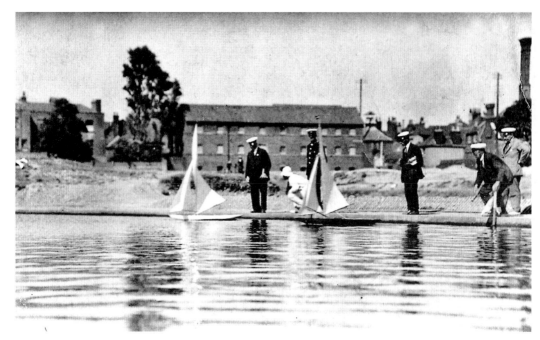

The model yacht pond was one of several capital works set up to provide employment in the years after the First World War. Formerly known as the cocklepond, extensive improvements were made before its reopening in 1922. Young boys tried out their carved model yachts here for fun, while adults evidently took things far more seriously.

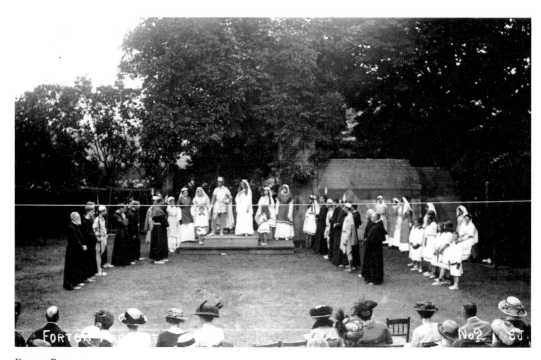

Forton Pageant, 1930.

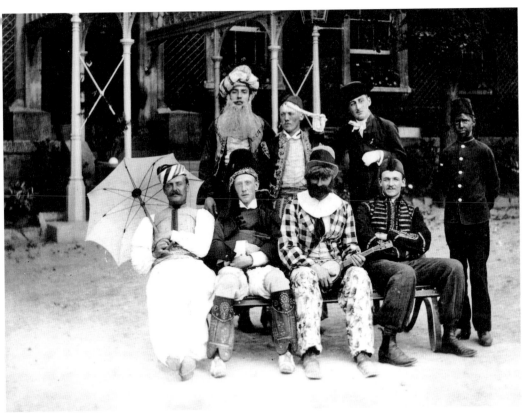

Forton Derby jockeys, 1885. The derby was an annual event on the recreation ground opposite Forton Barracks, and involved tall Royal Marine officers in fancy dress doing two laps of the ground on diminutive donkeys. This photograph was taken outside the officers' mess and quarters.

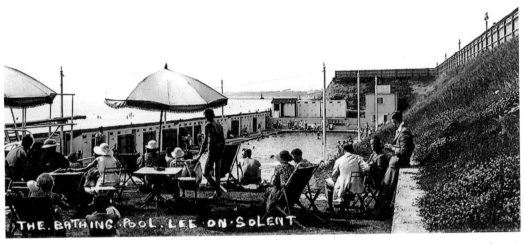

The Bathing Pool, Lee on Solent, 1930s. Alternatively, according to a guide in the 1920s, a stone throw's away, 'the beach at Lee slopes gently into the safe Solent waters. Low cliffs, fine shingle and stretches of firm sand make the surf very acceptable to children and adults'.

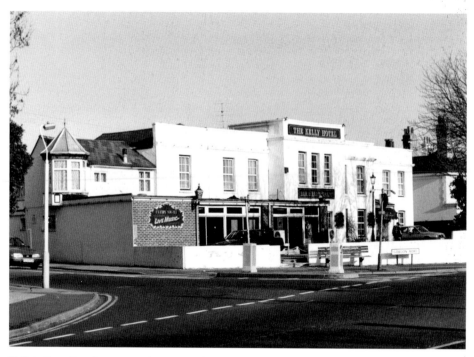

Kelly's, Bury Road, 1992. In the 1970s, the Tregantle Hotel boasted of having both hot and cold water, 'a lounge with a coloured television' and electric blankets. Later renamed Kelly Hotel, by the 1990s it was offering a four-poster bed and live music every night. Within a few years the building was converted into flats.

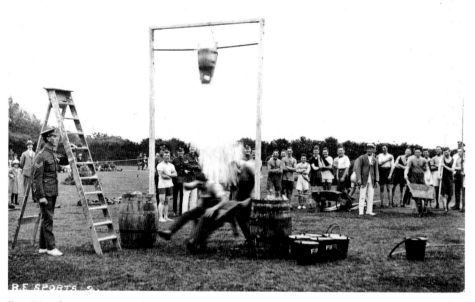

Fort Monckton, 1922. Royal Engineers put their expert military engineering skills to good use on sports day.

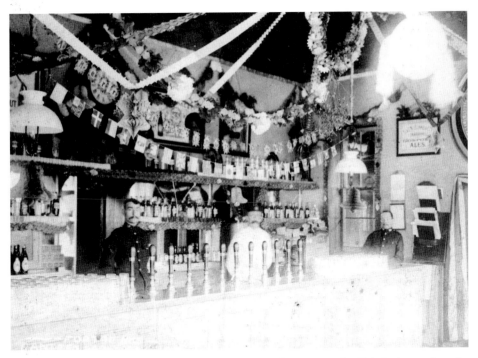

Forton Barracks bar, Christmas 1912. On the wall is an advertisement for Blake's ales, made at the company's brewery in South Cross Street, which stood on the site of the current police station.

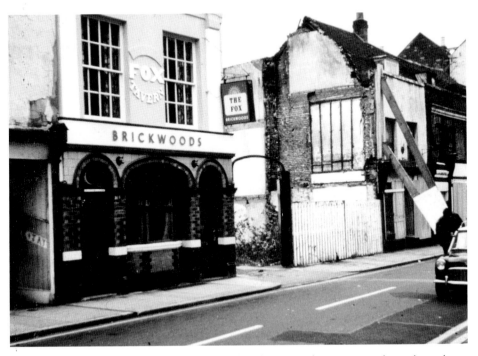

The Fox Tavern, 1970s. In the nineteenth and early twentieth century, twelve pubs and one brewery have been recorded as operating in North Street, though today only the Fox survives.

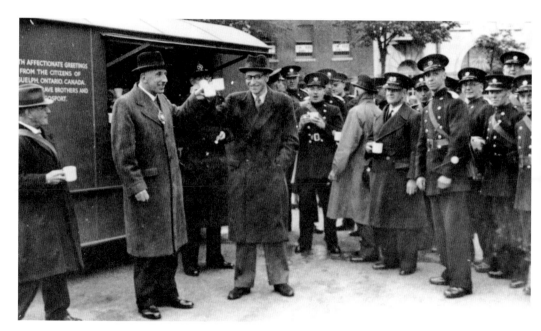

Cheers – to victory! Mayor Alderman J. R. Gregson (second from left) enjoys a cuppa with members of the wartime Auxilary Fire Service outside the Thorngate Hall in around 1940. The notice on the mobile canteen states that it was generously provided by citizens of Guelph in Ontario.

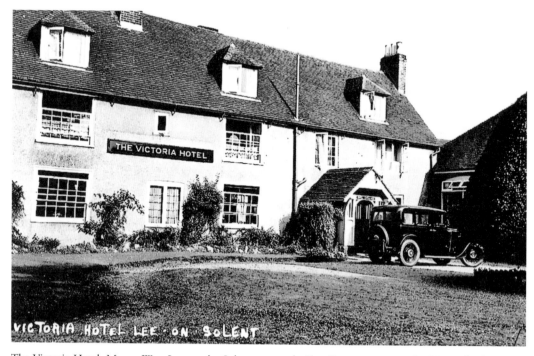

The Victoria Hotel, Manor Way, Lee-on-the-Solent – now the Bun Penny – was run by Mary Fletcher in the 1930s when this photograph was taken. The building has medieval origins and was a farmhouse from at least the seventeenth century.

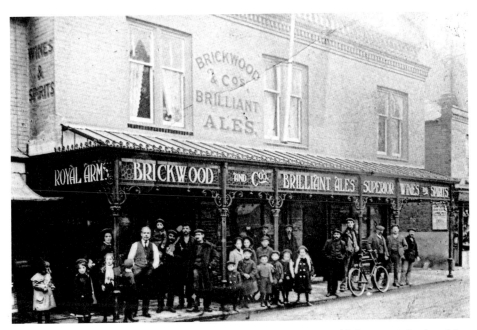

The Royal Arms, Stoke Road, shortly after the glazed canopy was added, *c.* 1908. In the 1860s, this was a beer house with its own brewery. Coroner's inquests on local people were regularly held on the premises. In 1864, for example, an inquest was held on William Smart of Jamaica Place, a stonemason, who died after falling from a ladder. In 1902 the law was changed to prevent inquests on licensed premises.

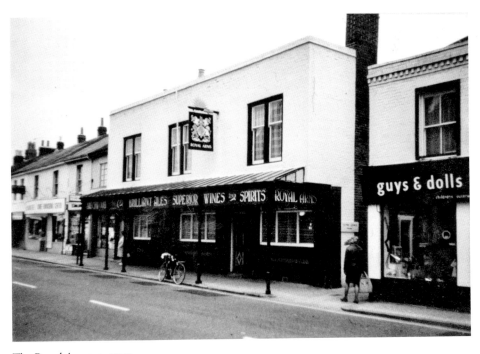

The Royal Arms, *c.* 1975.

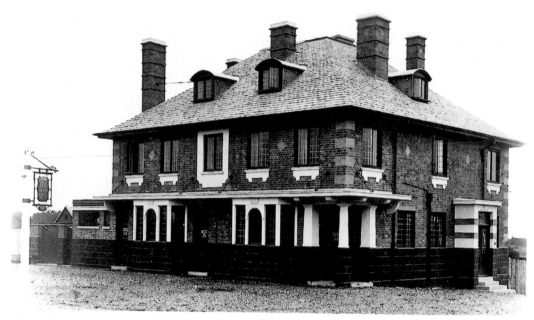

The Inn by the Sea, Lee-on-the-Solent, shortly after construction, *c.* 1926.

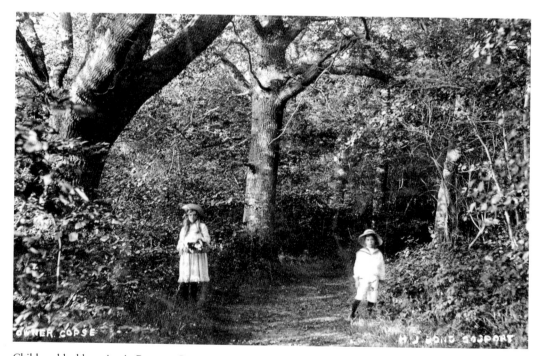

Children blackberrying in Rowner Copse, *c.* 1909. This rural idyll was not always so tranquil. In 1890, the cracking of musketry and blowing of bugles heralded 'The Battle of Rowner Copse', a mock fight involving locally based volunteer battalions.

Bury House, a seventeenth-century listed building, seen here in 1989, has been part of Gosport Community Association since the 1950s. The adjoining Thorngate Halls was the venue for some of the most popular acts of the 1960s, including Rod Stewart, Georgie Fame, Long John Baldry, The Yardbirds, Alan Price, Van Morrison, Manfred Mann, Them, and Dave, Dee, Dozy, Beaky, Mick and Tich.

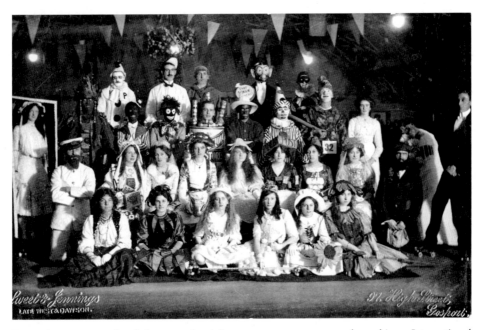

Fancy dress event, undated. Amongst the elaborate costumes are a man dressed in an International Stores tin (a company that had a branch in North Cross Street) and a person dressed as a monkey holding a sign saying 'Won't wash clothes', a reference to a Brooke's Soap Monkey brand slogan.

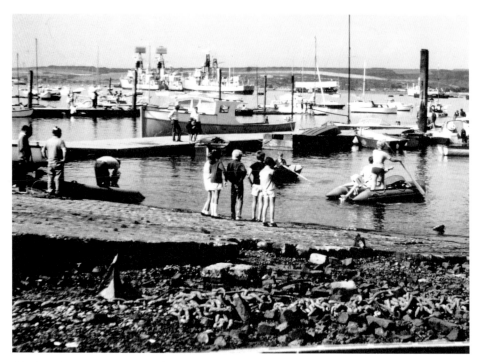

Messing about in boats at Hardway, *c.* 1970.

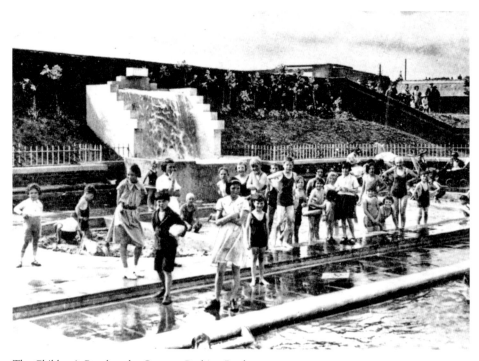

The Children's Pond at the Gosport Bathing Pool, *c.* 1939.

A Working Life

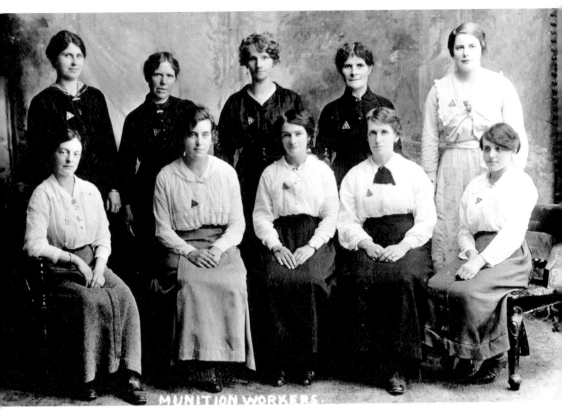

War workers at Gosport, 1916. Note the distinctive brass triangular 'On War Service' badges, which were issued to war workers, mainly those engaged in the making of munitions.

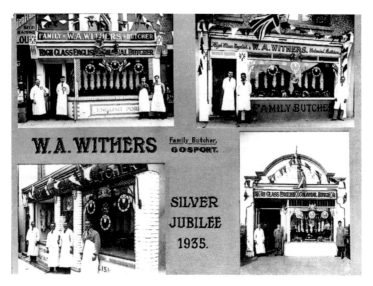

William Withers butcher's shops. The Stoke Road branch (*top left*) opened in 1928 and closed in 1984. Also shown are branches at Bemister's Lane (*bottom left*), Anns Hill Road (*top right*) and Grove Road (*bottom right*).

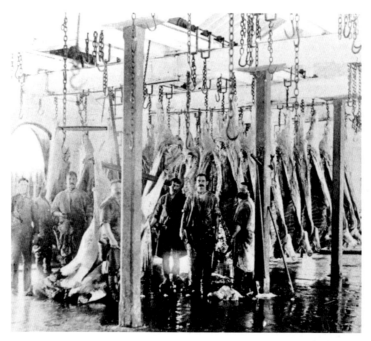

Abbatoir workers in the Royal Clarence Yard, *c.* 1901. The victualling yard's slaughterhouse on the quayside could kill hundreds of animals on a daily basis. Cattle arrived either 'on the hoof' from local contractors, or were imported by ship and landed in the yard by a steam crane, herded into pens. There they were examined for signs of disease before slaughter. The meat store was destroyed in an air raid in early 1941.

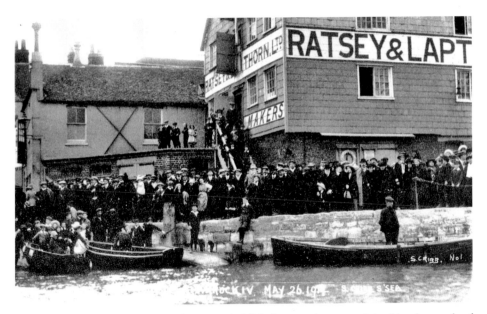

Ratsey & Lapthorn sailmakers and Camper & Nicholson workers were joined by thousands of local people to watch Sir Thomas Lipton's yacht, *Shamrock IV*, launched in 1914. The state-of-the-art yacht, designed by Charles E. Nicholson, utilised a metal called navaltum, had a skin of three thicknesses of wood, a 160-foot, hollow mast, and a size of canvas 'that takes away the breath'. However, its unconventional appearance led to it being called 'the ugly duckling' and it was an unsuccessful challenger for the 1920 America's Cup (see page 153).

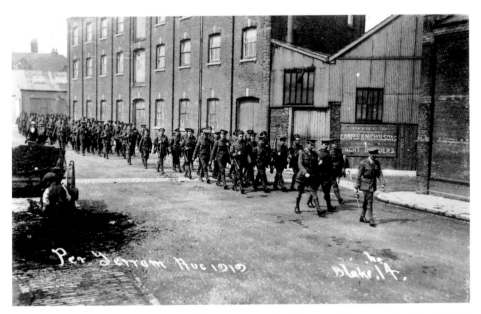

Camper & Nicholsons, 1919. *Shamrock IV* is estimated to have cost £70,000 to build and C&N was a major local employer. Royal Marine survivors of the First World War march past the company's offices.

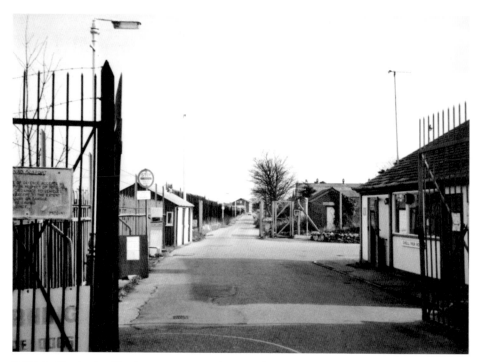

Priddy's Hard, the Hardway entrance. The powder magazine, associated storehouses and cooperage were completed in the 1770s, but the site was to develop from a basic gunpowder store into a major complex of sophisticated weaponry in its two-hundred-year history.

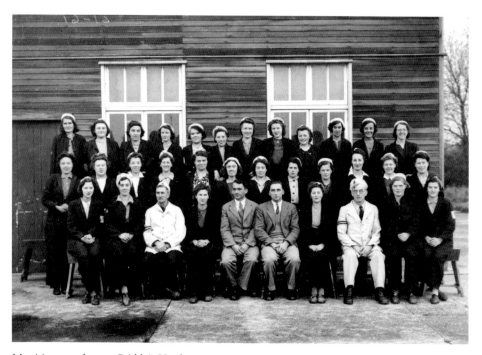

Munitions workers at Priddy's Hard, 1940s.

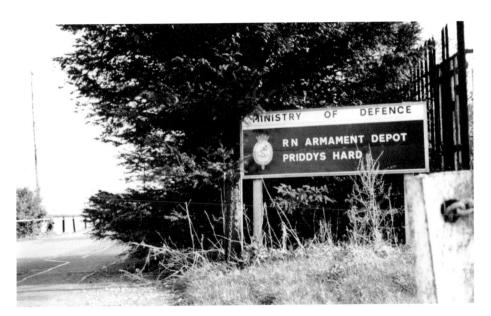

Priddy's Hard sign, 1993.

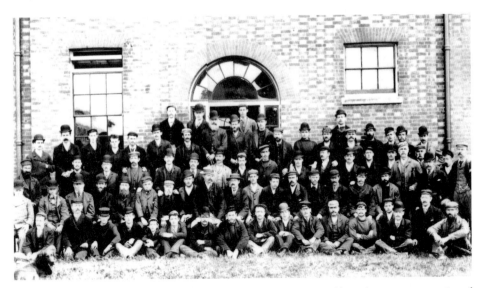

Storekeeper's House at Priddy's Hard, *c.* 1885, with workers. Unlike other group portraits of the period, it comes as no surprise that there are no smokers. Built in about 1777, the first storekeeper to occupy this building was Lt-Col. William Beache. In 1883, six workers were killed in an explosion that was initially blamed on Irish terrorists but was later found to have been an accident. All employees who handled explosives were required to wear special shoes and canvas suits. During the First World War, demand for cartridges and shells led to an additional fifty-five storehouses, laboratories and workshops being built and, for the first time, women were employed in the filling and repair of cartridges and shells. The number of workers trebled during the Second World War and included approximately 2,000 women by 1944, when all efforts were concentrated on preparations for D-Day. Following the Falklands War, the depot was run down and, in 1988, the remaining staff and stores relocated.

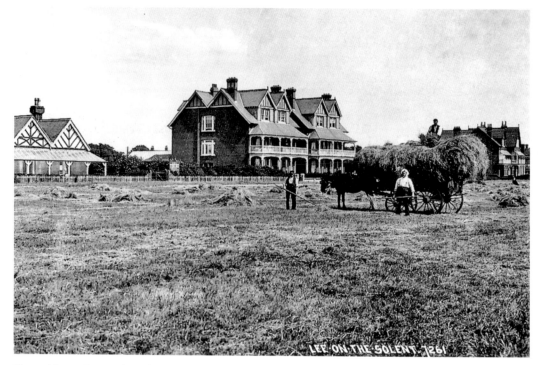

Haymaking at Lee-on-the-Solent, with Marine Parade in the background. This strip of land, 150ft wide, was reserved for leisure use early in Lee's development.

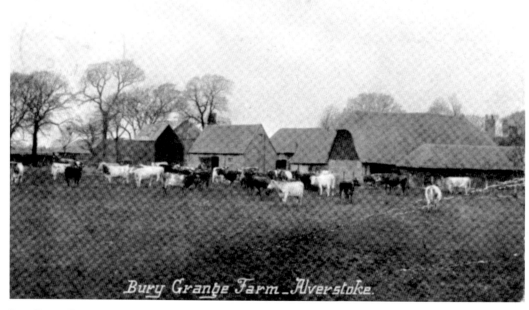

Bury Grange Farm, c. 1908, covered an area from Privett Road to Bury Hall Lane, and was primarily a dairy farm. Its produce was sold directly through an outlet in the High Street on the corner of Bemister's Lane.

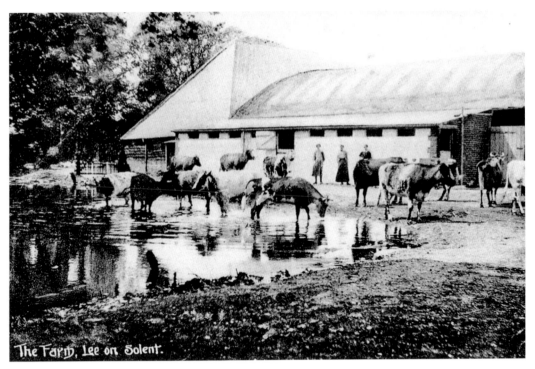

Cattle farming at Court Barn Farm in Lee-on-the-Solent, *c.* 1930.

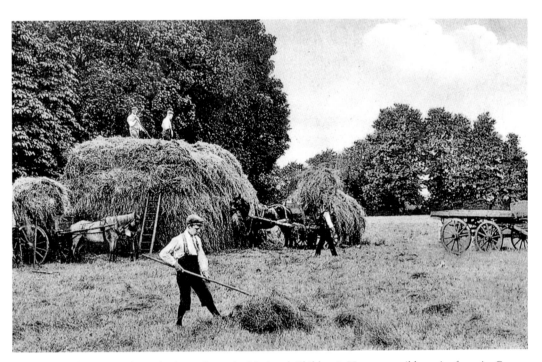

Haymaking carried out by boys from the National Children's Home, possibly at its farm in Gomer, *c.* 1910.

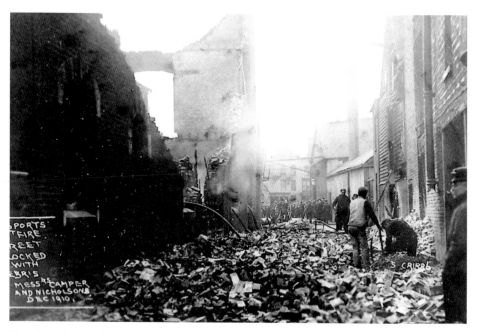

The Great Fire of Gosport on 23 December 1910 broke out in a warehouse at Camper & Nicholson's yard, eliciting a quick response from the brigade and an estimated 10,000 spectators.

Royal Marine guard, *c.* 1882, who was in charge of the subdivision guarding Priddy's Hard. On 14 April 1882, he captured two men who were 'rowing about in a suspicious manner' near the magazine on the north side of Priddy's Hard. They were found to have matches, a lantern and some percussion caps and were arrested, charged as 'suspicious persons' and locked up in the cells at Portsmouth Dockyard.

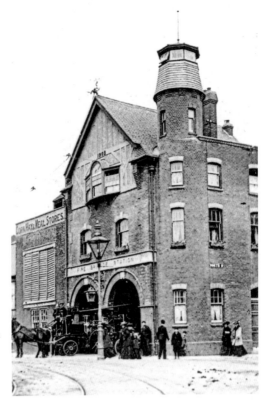

Gosport Fire Station, *c.* 1903. Gosport Fire Station on the corner of Clarence Road and North Street was purpose-built in 1901/02. The lookout tower afforded a panoramic view of the area. The premises of Walter French, the corn merchant, on the left was soon to be taken over by the Millard brothers (see page 38).

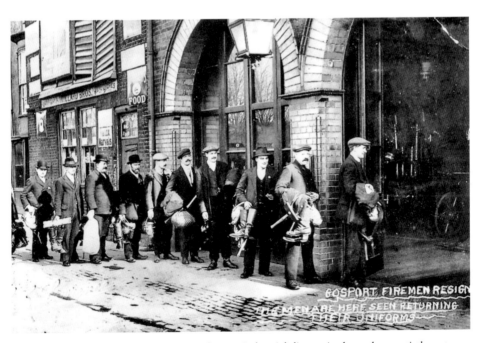

Gosport firemen resign *en masse* in an unknown industrial dispute in the early twentieth century.

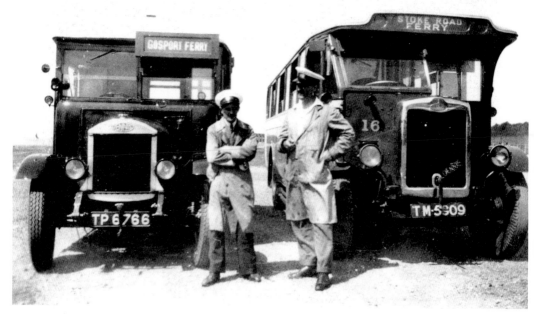

Bus drivers at Stokes Bay, Charlie Boyce and Les Wyles. The Provincial bus on the right served in Gosport between 1935 and 1950.

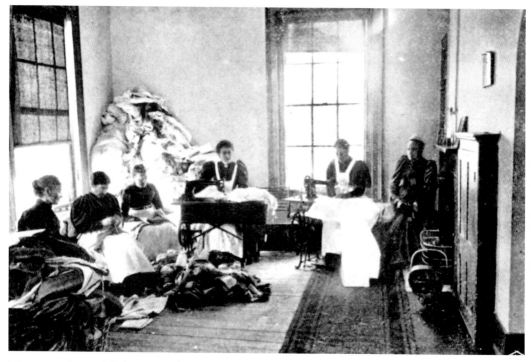

Women workers at Haslar sew and yarn patients' clothes at Haslar Hospital, c. 1897. In the early nineteenth century, the hospital raised money by selling off dead patients' clothing.

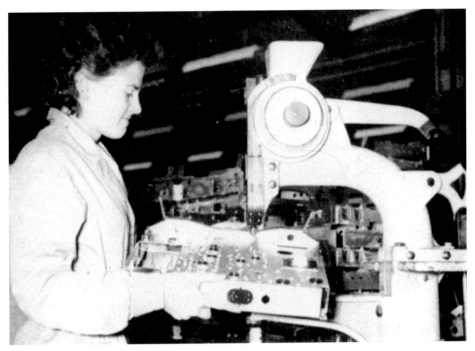

An Ultra worker in the late 1950s. This factory, which was to become the largest television assembly plant in Europe, was opened in 1956. In 1961, the company was taken over by the Thorn Group, which owned Ferguson, though it was not until 1974 that the factory was renamed.

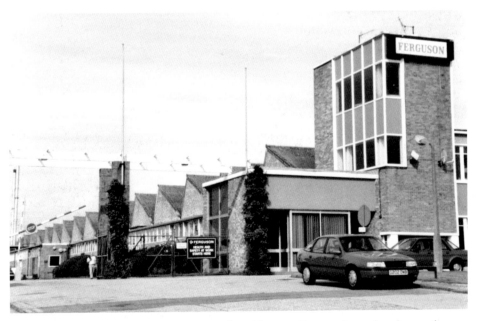

Ferguson's factory, Fareham Road, 1991. In the mid-1970s, Ferguson's employed around 3,400 people on the production of Ultra, HMV, Ferguson, Baird, DER and Marconiphone brands. Seven hundred jobs were lost when the factory closed soon after this photograph was taken.

Royal Clarence Victualling Yard. Grain vessels unloaded directly into the granary on the left, the cast-iron columns and heavy wooden joists bearing the immense weight. On the right is the flour mill and bakery.

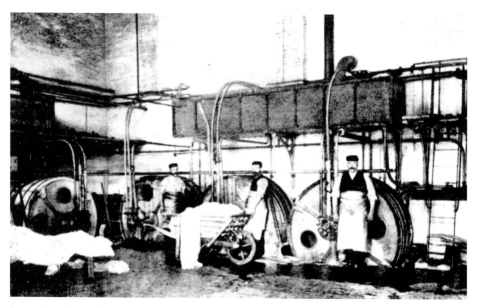

Steam laundry workers at Haslar Hospital, c. 1897. Unlike in former days, by the second half of the nineteenth century cleanliness was recognised as being essential to good health and recovery in hospitals.

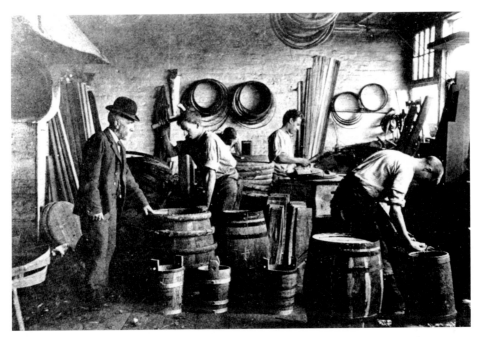

Coopers at Royal Clarence Yard making casks for salt beef, *c.* 1901. This was a job requiring precision skills to ensure airtight barrels to preserve food and protect from contamination during transportation to ships of the line.

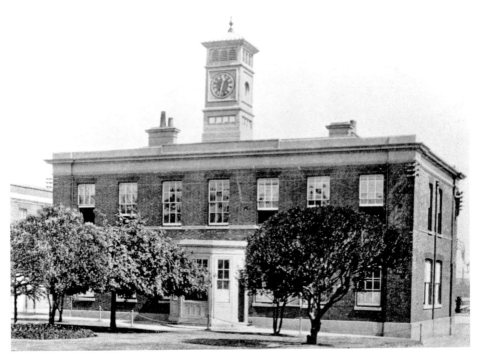

Royal Clarence Yard Offices of the Victualling Store Department, *c.* 1901.

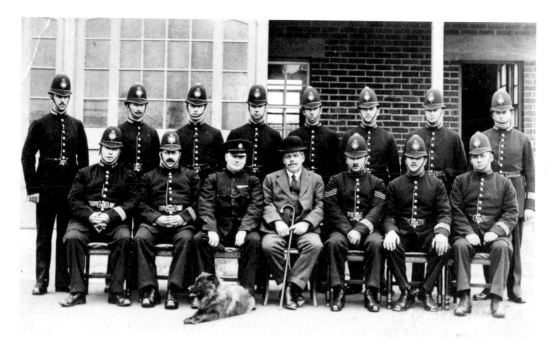

Gosport police at the old police station in South Street, which was bombed in the Second World War. Officers moved into a temporary station in Bury Road until the opening of new premises in South Street in 1957.

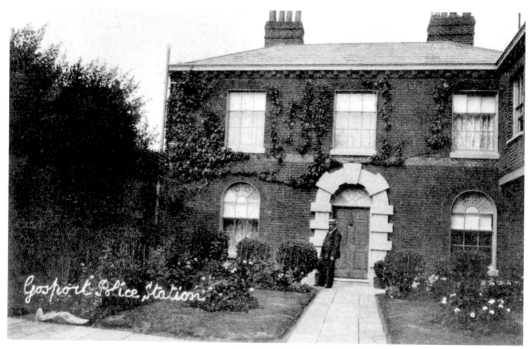

Gosport police station, c. 1907. At this time the Superintendant was James Cottle, under whom there were three sergeants and eighteen constables. One constable was stationed at Alverstoke, Brockhurst and Hardway, while there were two at Newtown and Forton. There was also a 'Water Police Station'.

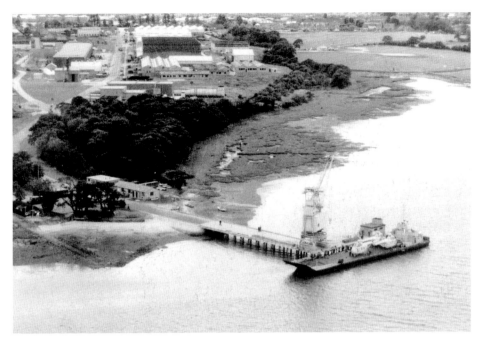

Foxbury Point, *c.* 1957, showing Wessex Whirlwind helicopters on a vessel docked at Fleetlands' pier.

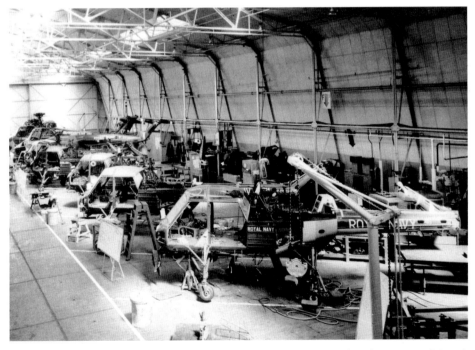

Fleetlands, Fareham Road, *c.* 1970. Westland Wasp helicopters, seen here being reconditioned, were light anti-submarine strike helicopters which operated from small ships and carried two Mk 44 homing torpedoes.

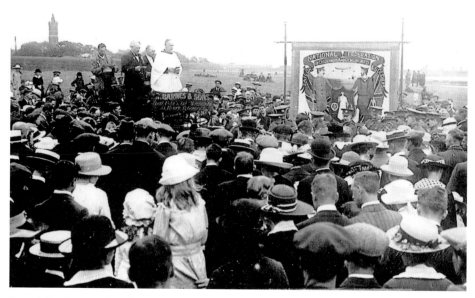

Demobilisation meeting, the Horsefield (later Walpole Park), *c.* 1918. The National Federation of Discharged and Demobilised Sailors and Soldiers was formed in 1917 to fight for fair treatment, one concern being their reliance on charity rather than having an entitlement to decent pensions. Some branches set up soup kitchens, such was the poverty in some areas. The group was later to merge with other veterans' organisations to form the British Legion. This photograph is believed to show a church parade that took place before or after a march through the town.

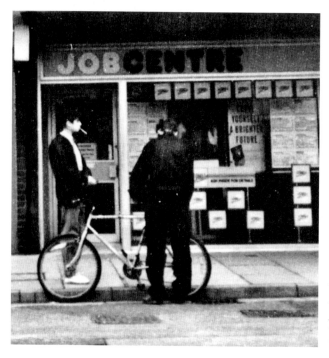

The Jobcentre, High Street, 1980s. National unemployment reached a record three million under the Thatcher government in the 1980s. A sign in the Jobcentre window exhorts unemployed people to 'Carve Yourself a Future'.

Getting About

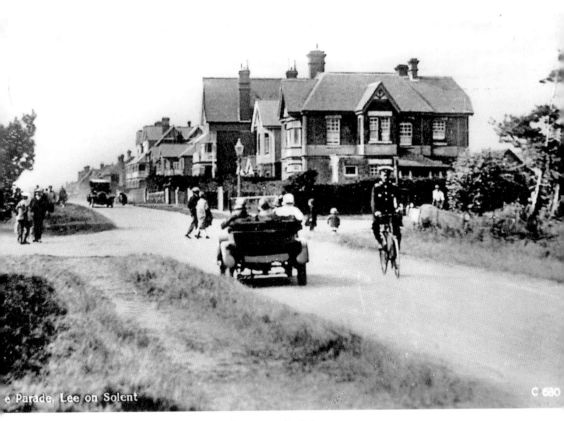

e Parade, Lee on Solent

C 680

Traffic on a sunny day on Marine Parade, Lee-on-the-Solent, *c.* 1925.

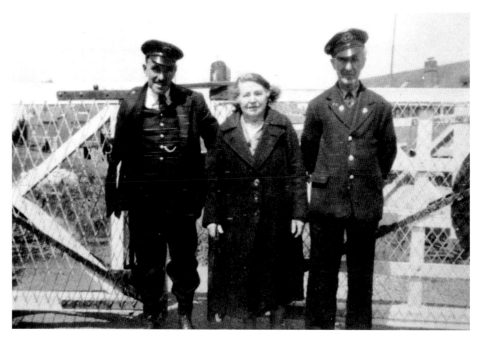

Gatemen at Cambridge Road railway crossing, 1930s. Mr Gould (*left*) operated the gate for many years and is seen here with a fellow railway worker and Mrs Higgins of Nightingale Terrace.

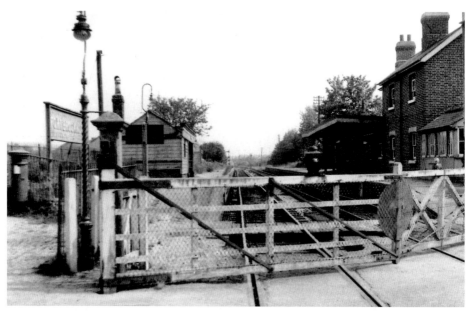

Brockhurst railway station was opened in 1865 and renamed Fort Brockhurst in 1893 to prevent travellers arriving and believing, very briefly, that they were arriving at Brockenhurst in the heart of the New Forest. The station was often used by the military to transport troops to and from Fort Brockhurst, which served as a discharge depot.

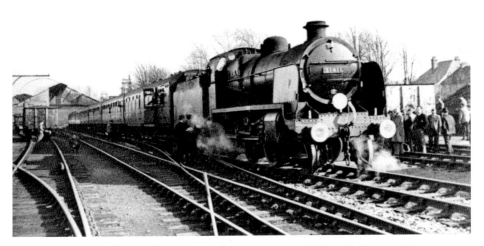

Trainspotters at Gosport railway station admire a Mansell N Class locomotive No. 31411 on 20 February 1966. This train arrived at the station at 1.56 p.m. and left at 2.11 p.m., taking 16½ minutes to arrive at Fareham Station.

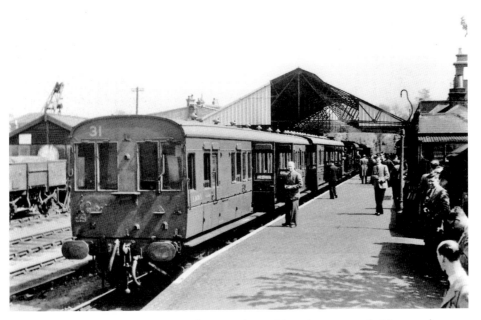

A view of a platform at Gosport railway station, with trainspotters admiring another rare 'special', c. 1960. The station was opened in 1841, built outside of the fortified town as the Commanding Officer refused to allow the walls to be breached. The line was heavily used for coal and other freight during the nineteenth century. From 1953 the station was used for goods trains only, until final closure in 1969.

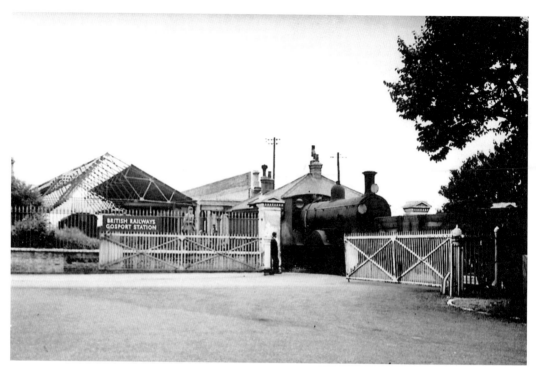

A locomotive is seen on the Royal Clarence Line, a 600-yard extension to the victualling yard, used by Queen Victoria to enable her to cross the Solent for Osborne House.

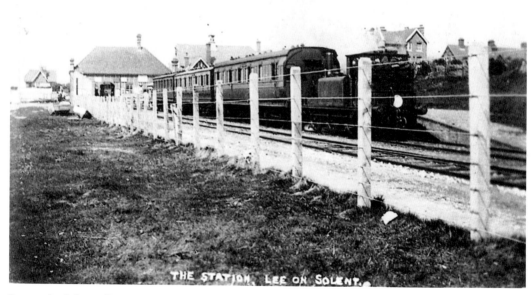

Lee-on-the-Solent railway station, c. 1920. This line, which opened in 1894, joined the aspiring seaside resort with the main network at Fort Brockhurst Station. The line closed in the 1930s.

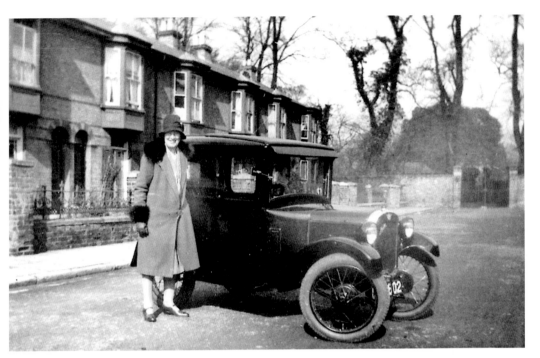

Prince of Wales Road, *c.* 1927. A new car was an obvious status symbol when there were so few on the roads, and one could park it outside one's house and happily refute any accusations of showing off. The gates of the Grove are visible at the end of the road.

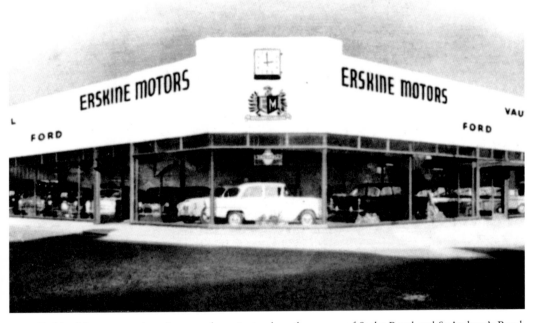

Erskine Motors, seen here in around 1956, stood on the corner of Stoke Road and St Andrew's Road, and was the place to go for the latest models.

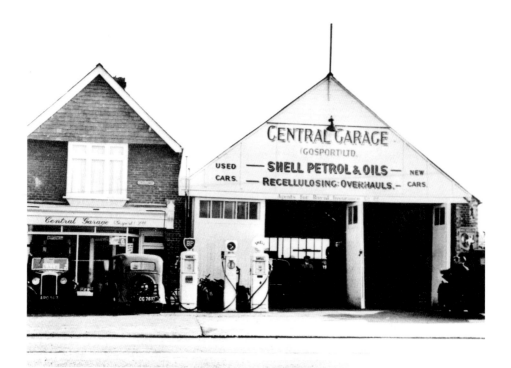

Central Garage, The Crossways, offered service and repair by highly skilled mechanics, a choice of BP or Shell petrol, and new or used cars. It is seen here in around 1950.

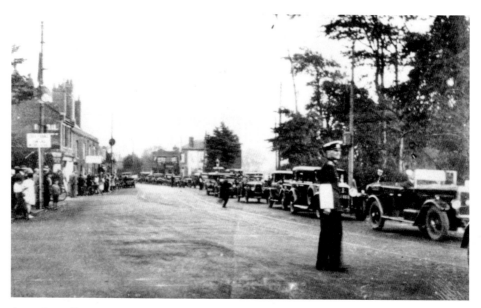

An early traffic jam in Gosport, in the days before it became a daily occurrence. The occupants of these motionless vehicles are *en route* to Stokes Bay to watch seaplanes flying at 300 mph over the Solent in the Schneider Trophy Contest. PC Wren directs the traffic at the junction of Brockhurst Road and Military Road in 1929.

Floating Bridge top deck, 1949. The original floating bridge, or chain ferry, was designed by civil engineer James Meadows Rendel who developed an idea that a steam vessel could warp its way along a chain cable, taking it up between rollers on the bow and dropping it into the sea at the stern. It was built at Bristol and towed into Portsmouth Harbour in December 1849 where it was greeted by thousands of spectators. A second floating bridge was bought soon after and the pair were named Victoria and Albert.

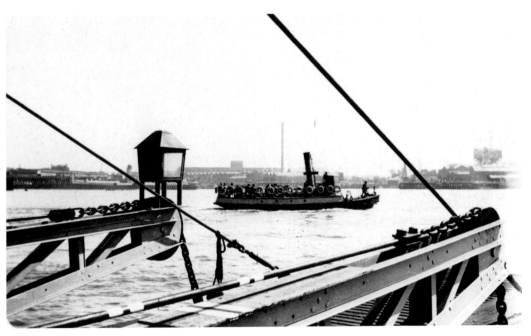

A steam ferry in Portsmouth Harbour, taken from the floating bridge in the 1930s.

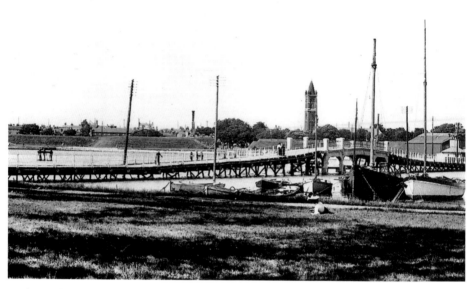

Haslar Bridge, *c.* 1920. Flux's Laundry chimney, the ramparts and Holy Trinity provide bearings.

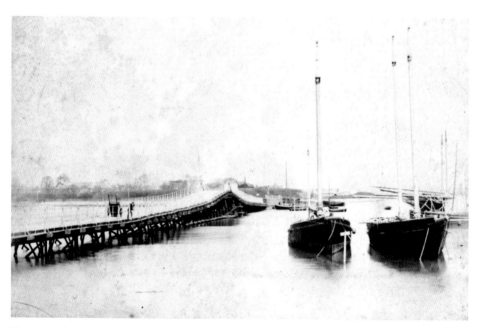

Haslar Bridge, April 1888. The first bridge built across Stoke Lake linked Haslar Hospital to a point where a windmill stood on the Gosport side. Forbes Bridge was named after the merchant who built it in the early 1790s, but was destroyed in 1801. A bridge built by the Royal Engineers lasted only three years, but a more long-lasting structure (seen here) eventually replaced it in 1835, built by developer Robert Cruickshank.

Jackie Spencer's bridge over Stoke Lake, seen here shortly after this section of the Stokes Bay railway track had been removed. The bridge was named after the railway gatekeeper who worked there for many years up until around 1902.

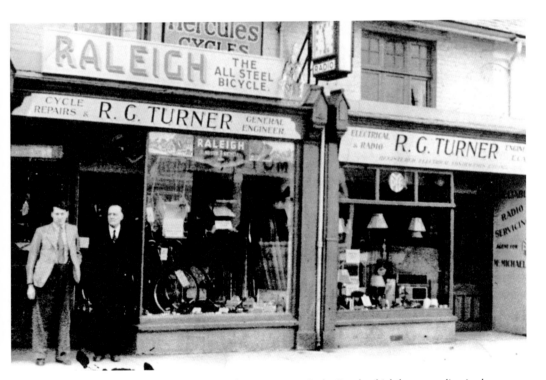

R. G. Turner's cycle and electrical repair shop at 183–85 Stoke Road, which began trading in the 1930s.

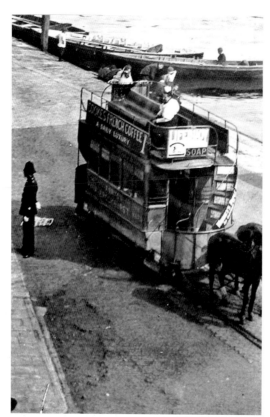

Horse tram, on the waterfront, *c.* 1887, taken from a tinted glass slide. A horse tram service was operating from at least the late 1850s, providing a service for travellers for the brief journey from the railway station to the floating bridge. Provincial's horse trams began running in 1882, after car sheds and stables had been constructed behind the India Arms hotel in the High Street.

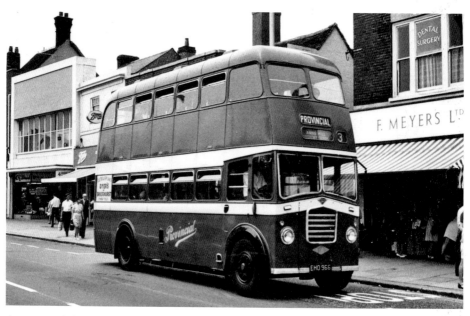

A Provincial double-decker in the High Street, *c.* 1959. This bus was built in 1943 and served passengers until 1970.

Cradle to Grave

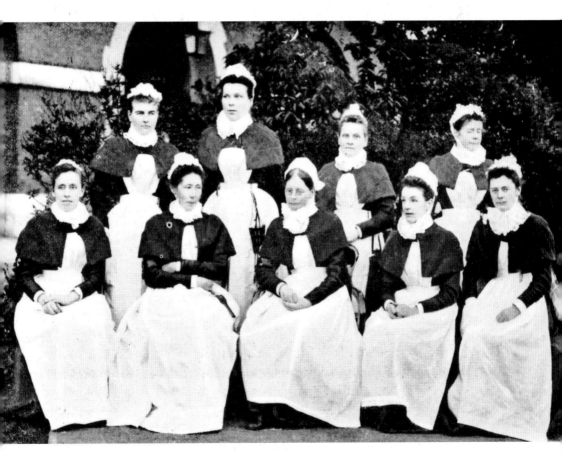

Nursing staff at Haslar Hospital, *c.* 1897. The nurse with spectacles (centre) was Miss Louisa Hogg, the Head Sister. The introduction of female staff at the hospital was reported to have had 'a restraining influence on Jack's proverbial command of words'.

The Isolation Fever Hospital was built by the Gosport brewer Thomas Blake in 1898. This block treated patients with enteric (typhoid) fever.

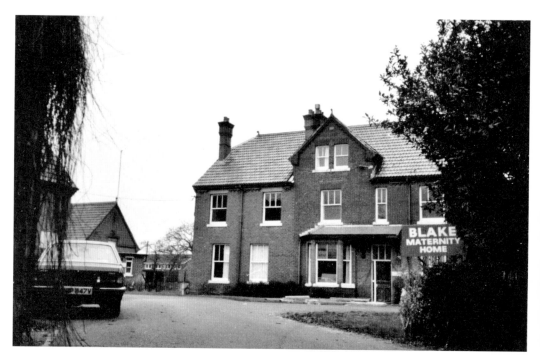

Blake's Maternity Home, seen here in 1989. By the 1950s, the Isolation Hospital buildings were serving the town as Blake's Maternity Hospital. Some of the original buildings have remained following conversion into residential housing.

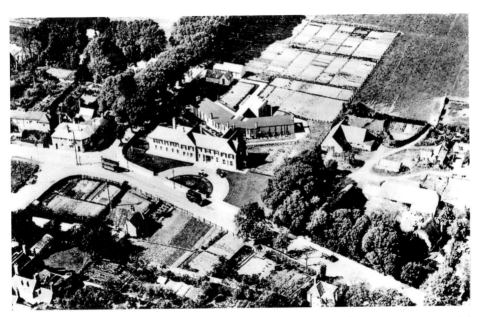

Gosport War Memorial Hospital, *c.* 1925. Gosport people raised £45,000 to erect the hospital on a three-acre site in Bury Road in memory of British servicemen killed in the First World War. Perhaps fittingly, the foundation stone was laid by Field Marshall Earl Haig, Kt, GCB, OM, GCVO, KCIE, who, despite his impressive post-nominals, was credited with having been responsible for the deaths of hundreds of thousands of British soldiers on the Somme. Until it became part of the National Health Service, the hospital was run by charity, with nursing staff but no doctors. Local opposition saw off a serious threat of closure by the Thatcher government in the early 1980s.

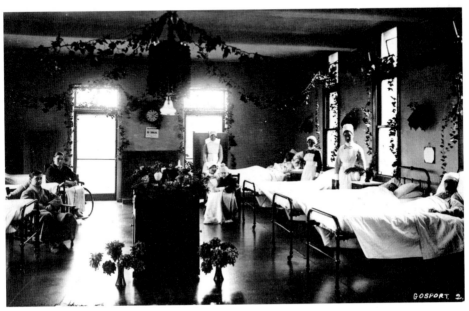

Gosport War Memorial Hospital ward, Christmas 1925. Decorations were put up, but one suspects some patients would rather have seen the 'No Smoking' sign come down.

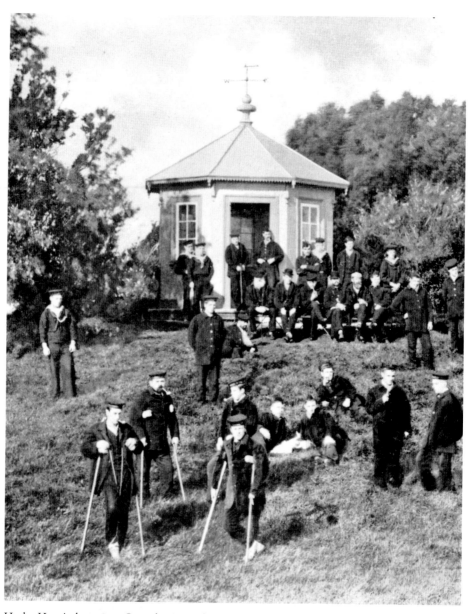

Haslar Hospital, *c.* 1897. Convalescing sailors with clay pipes are visible in the foreground in this view of the airing grounds, which were thoughtfully provided with smoking pavilions.

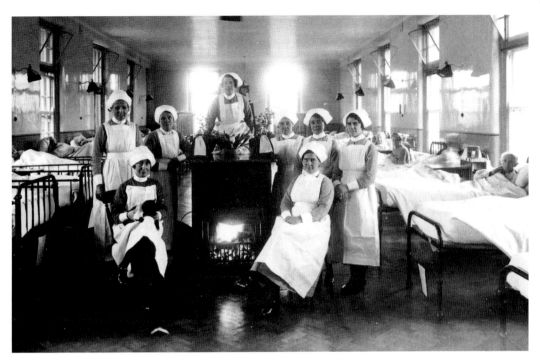

Sisters at Haslar huddle round a real coal fire (undated).

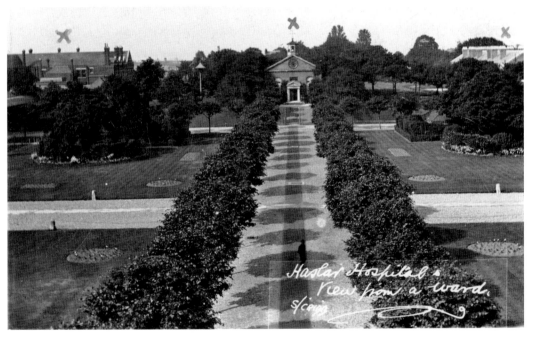

The view from a Haslar ward, *c.* 1914. This postcard is marked by the sender, Bella (presumably a nurse), left to right: the home where she lived, the church and the Officers' Quarters.

Haslar Hospital, *c.* 1909. This tree-lined avenue linked a landing stage in Haslar Creek to the main hospital entrance, along which the sick and wounded were delivered in hand-pushed carts along the rails seen here.

Haslar Hospital grounds, *c.* 1910.

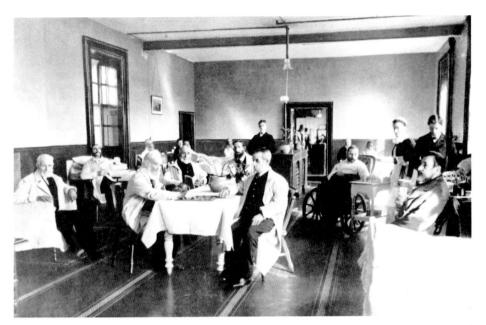

Pensioners' ward at Haslar, *c.* 1897. The favourite time of day for these old salts in Benbow Ward was described as 'grog time'.

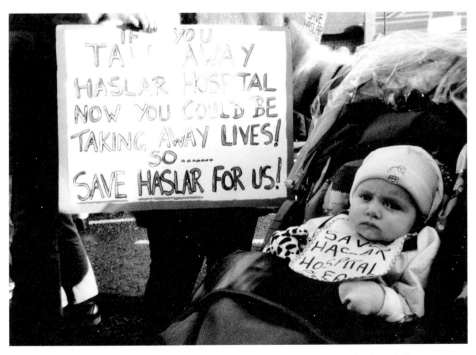

The march to save Haslar Hospital, 24 January 1999. Over 20,000 people, from babies to senior citizens, protested against the intended closure on the streets of Gosport. Haslar treated 111,000 patients a year and 27,000 Accident & Emergency cases at that time. The 23-acre site with 75,000 square metres of buildings was sold to a developer in 2009 for £3 million.

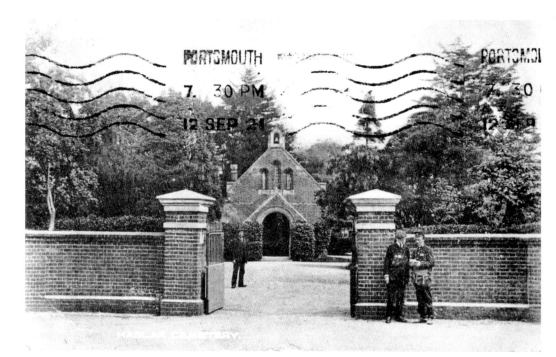

Entrance to Clayhall cemetery on a postcard dated 1921.

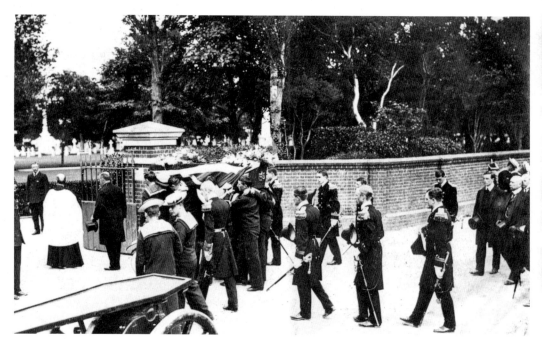

Naval funeral at Clayhall cemetery, 1907.

Streets and Homes

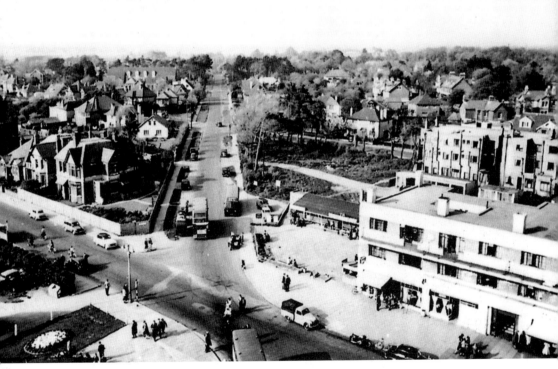

A view from Lee Tower looking up Milvil Road, *c.* 1950.

Pier Street, Lee-on-the-Solent, *c.* 1900.

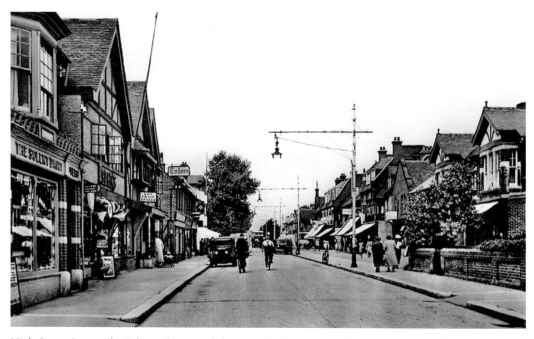

High Street, Lee-on-the-Solent. The row of shops on the left includes Tudor's, which provided gowns to the ladies of Lee for many years.

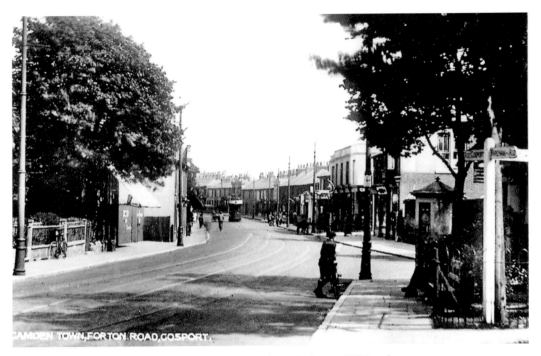

Forton Road as seen from the traffic island at the end of Anns Hill Road, *c.* 1920.

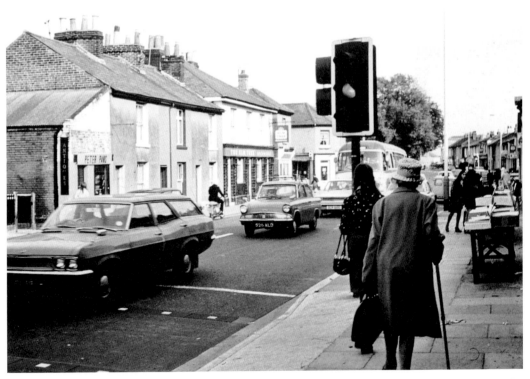

Forton Road in the 1970s. The moped rider is between Peter Pan's Antique shop and the Elm Tree pub.

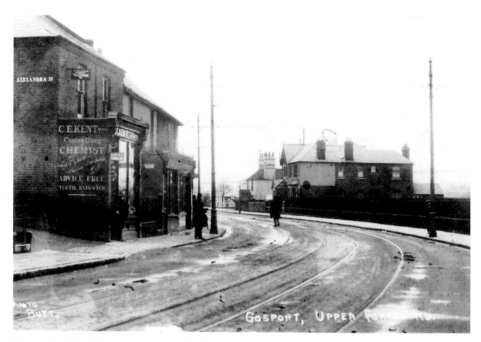

Forton Road looking east, *c.* 1915. Charles Kent's chemist shop on the corner of Alexandra Street is offering 'teeth extraction'. In the distance a solitary tree can be seen on what was to become Forton Rec, an area previously occupied by the Mill Pond.

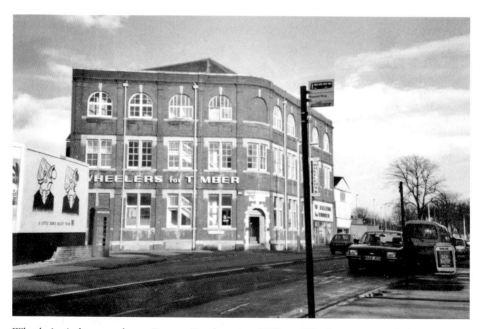

Wheeler's timber merchant, Forton Road, 1989. William Wheeler set up a lathe rendering business in Portsmouth in 1877 and by 1921 was importing timber and preparing it for sale to builders. In 1925 his son H. J. Wheeler opened a timber yard in Gosport and in 1934 the family business became a limited company.

Elson Road, *c.* 1920, at the junction with Frater Lane (*left*) and Elson Lane (*right*). On the left is the post office, on the right the churchyard wall.

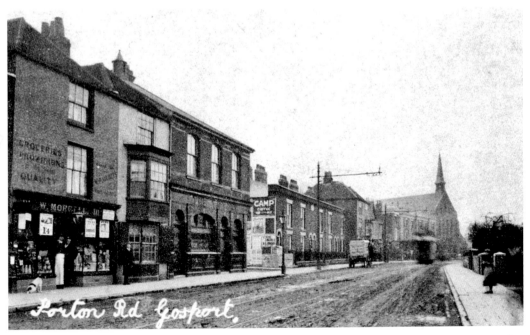

Forton Road , *c.* 1907. On the near corner of Park Street is the Victory pub, which was demolished in 1981.

Forton Military Prison in Lees Lane was built in around 1850. The 150 cells were watched over by ex-servicemen serving as warders, some of whom lived on-site. The photograph below shows the warders quarters and the remains of the prison wall on the right. By the 1910s it was called the 'Detention Barracks'. It was closed in 1927 and the site is now occupied by flats and a working men's club. These views date from the 1960s.

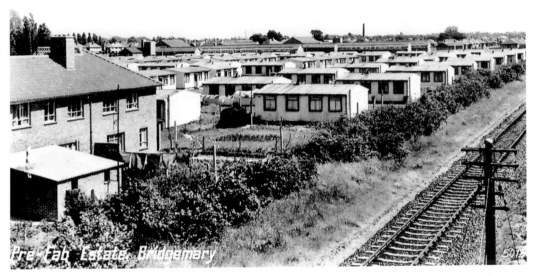

Pre-fabs (pre-fabricated houses), Bridgemary, *c.* 1946. Two hundred units were built on this estate as a temporary measure to alleviate the housing problems caused by enemy bombing before more permanent housing was constructed.

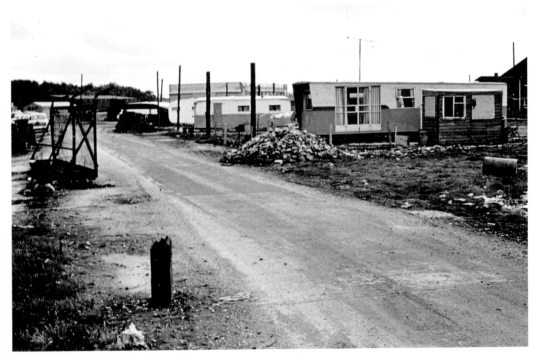

Naval caravan site on the former Grange Airfield in the 1960s.

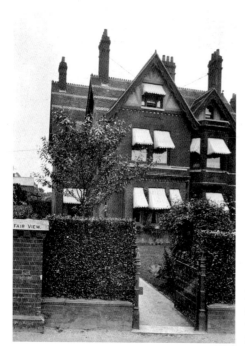

Fair View, Alverstoke: the residence of
Surgeon Rear Admiral Sir George Welch,
who died in 1947 and is buried in the old
St Mark's churchyard.

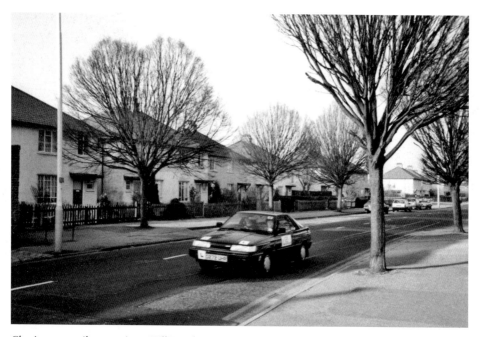

Cheriton council estate, Anns Hill Road, 1989. Built in the 1920s, each family house was provided
with a good-sized garden but, when the site was redeveloped in the 1990s, a large part of the area
was sold for private development and smaller houses and gardens were provided for tenants.

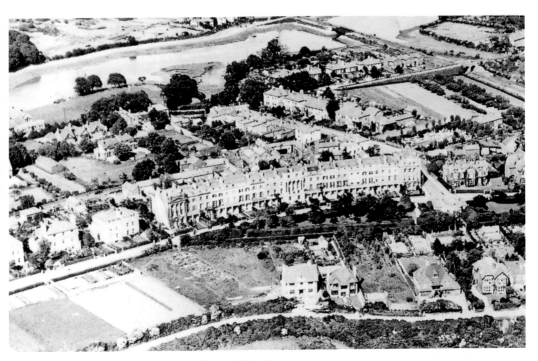

The Crescent dominates this aerial view of Anglesey, *c.* 1925.

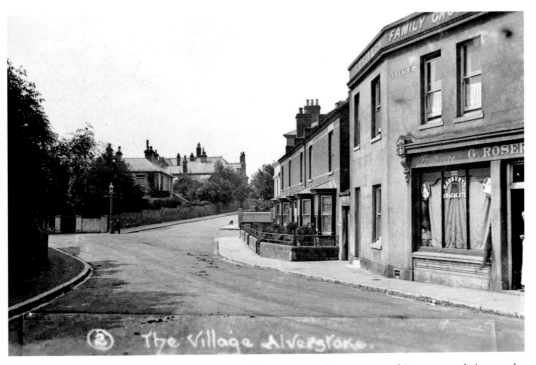

G. Roser's grocery shop in Village Road in the 1920s. By the late 1930s this store was being run by Bessie Roser.

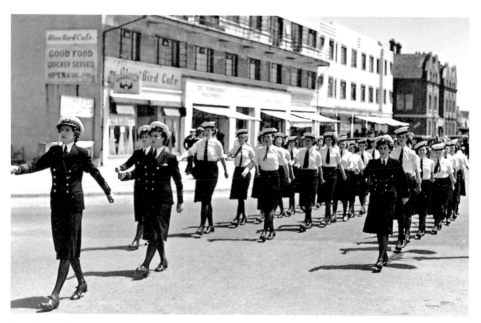

Marine Parade, Lee-on-the-Solent, a post-war view showing Wrens marching past the Blue Bird Café.

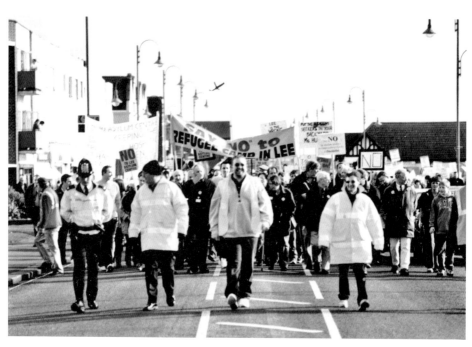

Anti-refugee march, Marine Parade, 2003. 8,000 residents took part in a march opposing plans to use the Daedalus naval airbase as a temporary holding centre for refugees. During the campaign *The News* reported that the owner of the Blue Bird Café, a pastor of a local church, called for tolerance and had two of his café windows smashed. Banners on the march included the slogan 'Lock up your daughters'. On the right is the former Gosport MP, Sir Peter Viggers, who spoke at a rally on the seafront and was later disgraced in the Parliamentary expenses scandal.

Council flats, Gosport waterfront, *c.* 1965. Stephen Weeks, a sixteen-year-old schoolboy from Alverstoke, took on the council over its post-war demolition programme, citing its demolition of fifty-six listed buildings between 1947 and 1965 in favour of blocks of flats. Stephen, a pupil at Portsmouth Grammar School, managed to briefly prevent demolition of 'The Hall', previously known as Stanley House (seen on the right), which had once served as Holy Trinity vicarage. His campaign was widely reported in the national press, but after three months the Minister of Housing decided not to intervene and demolition went ahead (see also page 160).

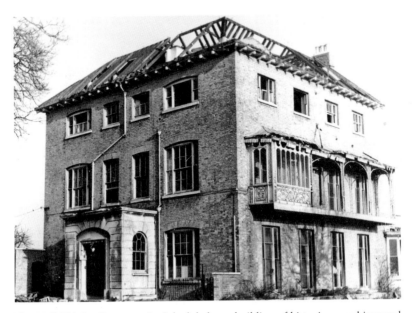

The Hall, Trinity Green, 1965. Scheduled as a building of historic or architectural importance, the house had a circular staircase and a lookout on the roof giving a panoramic view of the harbour and Solent, a view enjoyed by Ben Nicholson (head of Camper & Nicholson's) and his family in the nineteenth century.

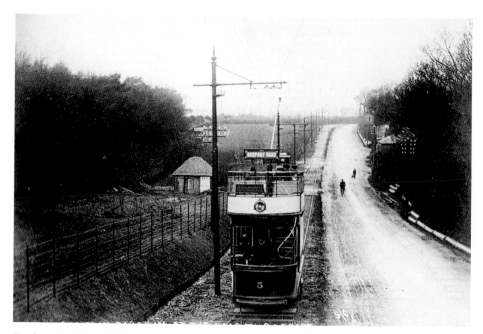

Fareham Road, near Hoeford, 1910s, a view that gives an idea of the rural character of the area that separated Gosport and Fareham. The old house in the dip of the road still exists. A tram depot and power station was built at Hoeford in 1904.

Mayfield Road, 1989. On the right is the Robin Hood pub, which dates back to at least the early 1870s, when it stood in a field and was run by John Light. Andrew Richardson followed as landlord and he was succeeded by his son Richard who was teetotal and claimed to be able to throw a cricket ball from the pub right across Haslar Creek.

In Defence of
the Realm

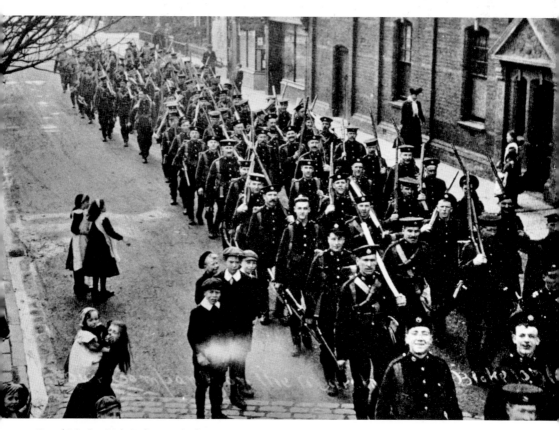

Royal Marine Light Infantrymen from Forton Barracks are seen 'on the march' through the town,
watched by local children, in 1913.

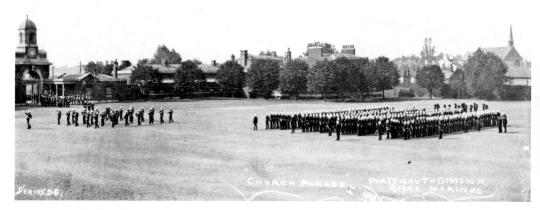

Forton Barracks Church Parade, *c.* 1909. On the left is the familiar main gate, and on the right is the marines' church, St John's. The arrival of the Royal Marine Light Infantry was an important factor in the expansion of what had previously been the rural hamlet of Forton.

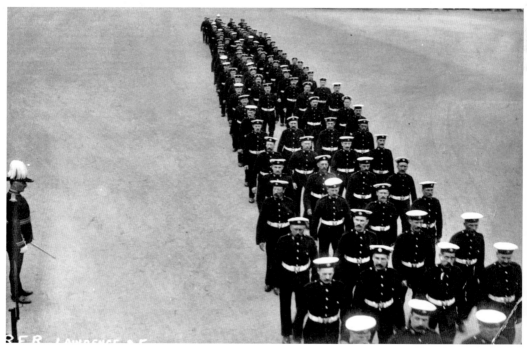

On the parade ground, *c.* 1914. Forton Barracks was said to have the largest parade ground in the country. However, the men who drilled on it were often seen as being inferior in physique and aptitude to those who were selected for the Royal Marine Artillery based at Eastney Barracks.

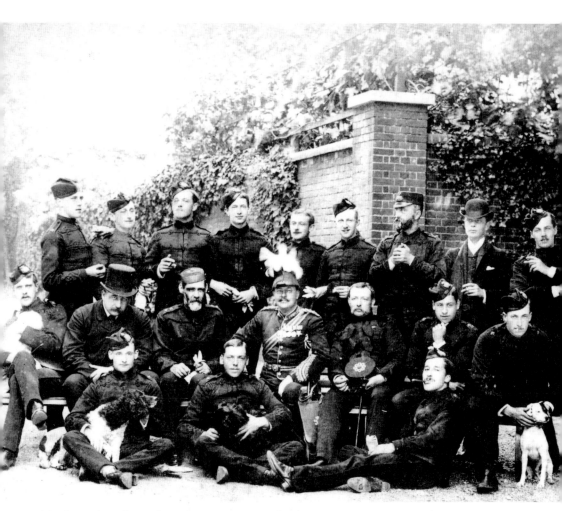

Members of a military class adopt various poses for the camera at Forton Barracks in February 1884. A few days after this photograph was taken, 600 men from the barracks marched to Royal Clarence Victualling Yard and embarked on the transport ship *Poonah* to fight in the Mahdist (or Anglo-Sudan) colonial war.

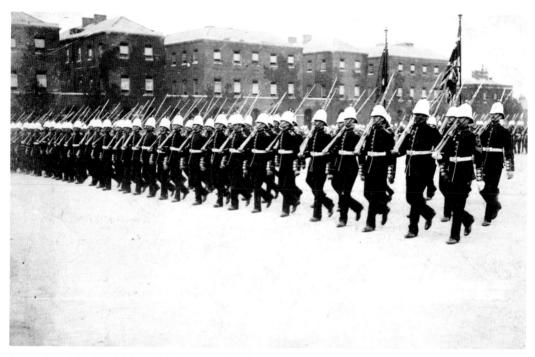

Inspection of the Royal Marine Light Infantry by the Lords of the Admiralty on Forton parade ground, *c.* 1914.

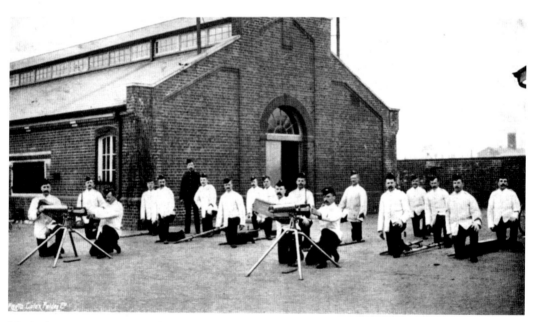

Maxim battery at Forton Barracks, *c.* 1907. Machine gun practice, using blanks, took place over Forton Creek while the use of live ammunition was safely confined to a Royal Marine launch at Spithead.

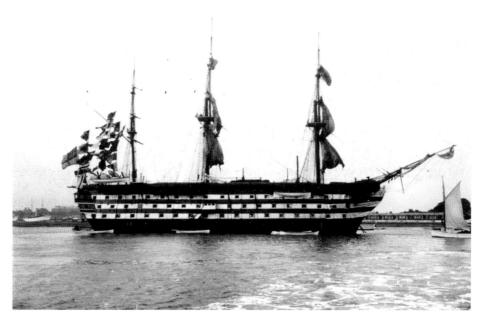

HMS *St Vincent*, *c.* 1895. In 1863, the *St Vincent* was converted into a training ship for boy recruits, and the old wooden ship became a familiar part of the harbour seascape for over forty years. In 1905, training at *St Vincent* transferred to Shotley, but in 1927 it was re-commissioned as a shore establishment at the Forton Barracks, which had been vacated by the Royal Marines.

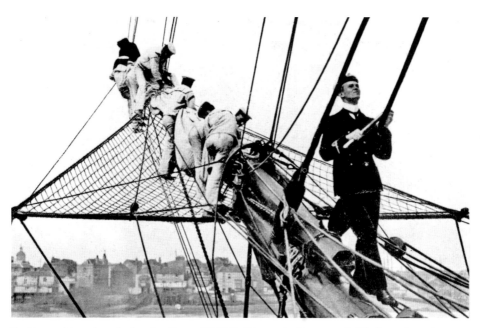

Furling and stowing the head sails on HMS *St Vincent* in Portsmouth Harbour. Recruits were provided with lodgings at a hostel in South Street and were a familiar sight on the streets of Gosport. At the time this photograph was taken (1903), the Admiralty had decided to abolish the sail drill in their training ships.

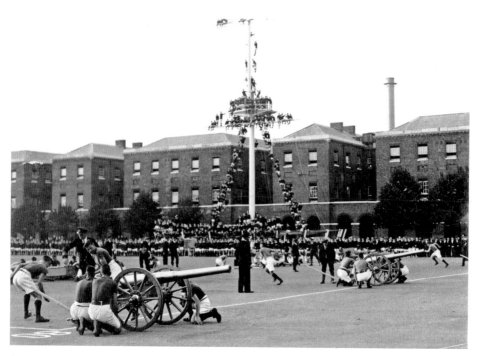

HMS *St Vincent* at the former Forton Barracks. The 110ft mast was installed in 1933 and provided a test of nerve and skill for thousands of recruits over the years. The record for climbing the mast stood at 68 seconds. The lower half of the mast was from the German battleship *Baden*, scuttled at Scapa Flow in 1919.

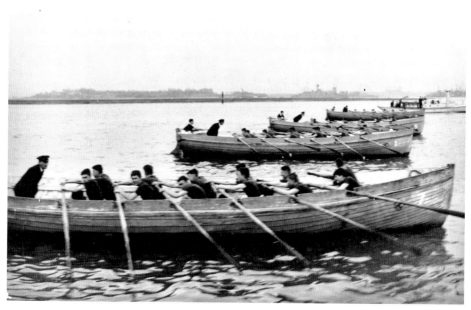

St Vincent boys getting ready for boat pulling in Portsmouth Harbour in the 1930s.

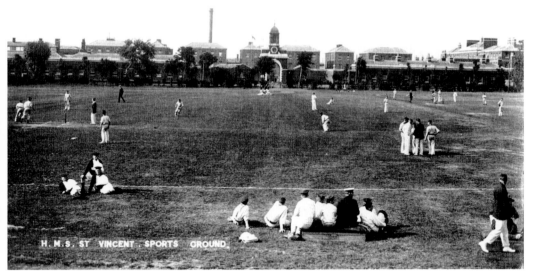

Cricket matches on HMS *St Vincent* sports ground, 1930s.

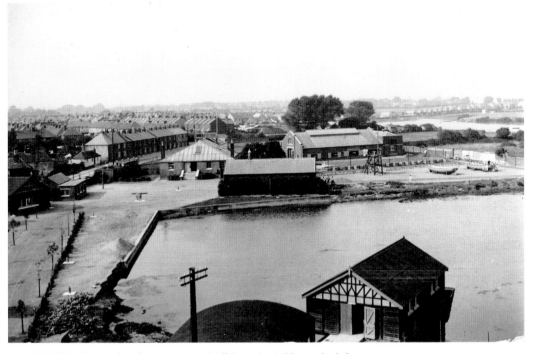

HMS *St Vincent* boathouse, 1930s. Mill Lane is visible on the left.

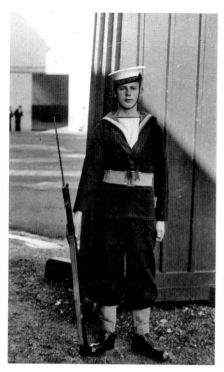

Portrait of a *St Vincent* recruit, believed to be D. Locke, who started his training at *St Vincent* in 1937.

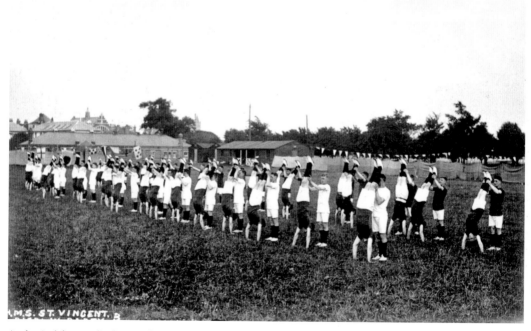

A physical fitness display on the New Barracks (St George) field, 1930s. The Thorngate Hall is visible on the left.

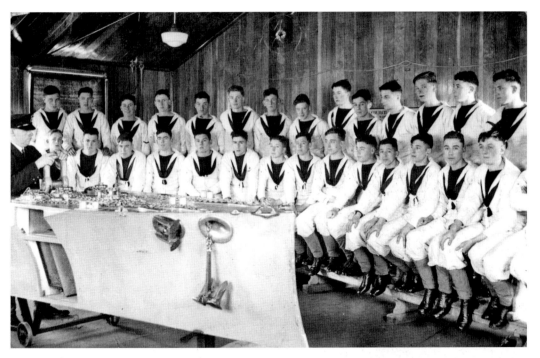

Anchor training at *St Vincent* in the 1930s.

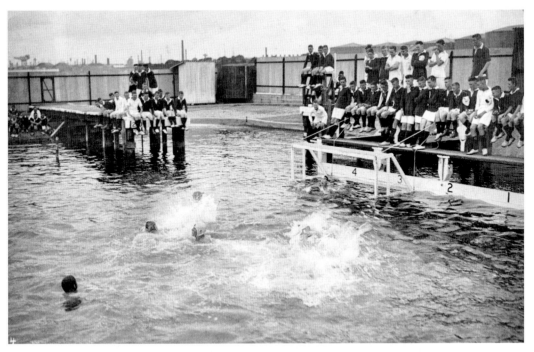

Water sports in the 1930s. HMS *St Vincent*, the 'nursery of the Navy', closed in April 1969.

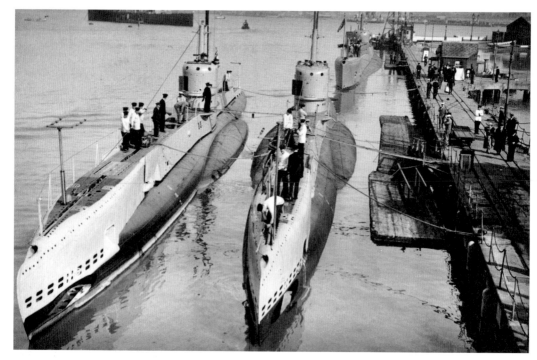

Submarines at HMS *Dolphin*, *c*. 1938. *Dolphin* was the home of the Royal Navy Submarine Service from 1904 to 1999, and location of the Royal Navy Submarine School. The submarine next to the jetty is HMS *Shark*, which was bombed and sunk off Norway in July 1940.

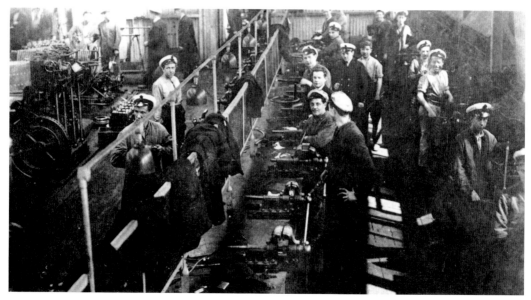

HMS *Fisgard* fitting shop, 1920s. Engine Room Artificers are seen in training, a few of the 700 to 1,200 'Tiffy boys' between the ages of fifteen and twenty that were there at any one time. Until 1932, *Fisgard* was made up of four old warships shackled together at the end of a long, rickety pier at Hardway.

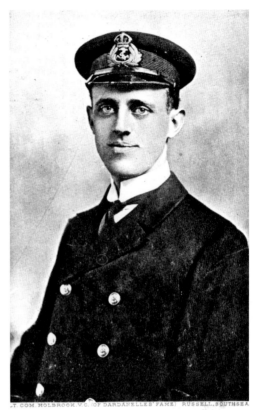

Norman Holbrook, *c.* 1915. Born in Southsea in 1888 and educated at Portsmouth Grammar School, in 1913 submariner Holbrook assumed his first command of the petrol-driven sub *A13* based at HMS *Dolphin* in Gosport. When war broke out he was commanding the *B11*, which had been built in 1906 but was already considered old and obsolete. On 13 December 1914, *B11* dived under five rows of mines in the Dardanelles and successfully torpedoed the Turkish ship *Mesudiye*. Treacherous currents and enemy torpedoes and gunfire did not prevent Holbrook from bringing his craft and men safely back to the Mediterranean. *B11* surfaced after being submerged for an incredible nine hours. Lt Holbrook was a local and national hero and was the first submariner to be awarded the Victoria Cross.

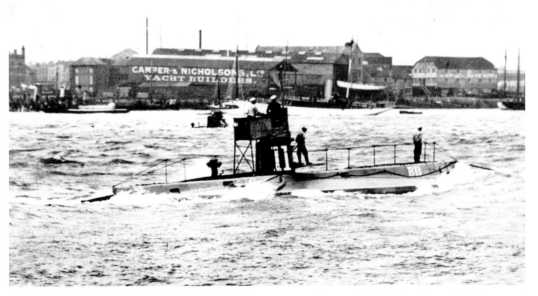

Submarine *B11* in Portsmouth Harbour, about to pass Camper & Nicholson's yacht builders, and Ratsey & Lapthorn's old sail loft, *c.* 1910.

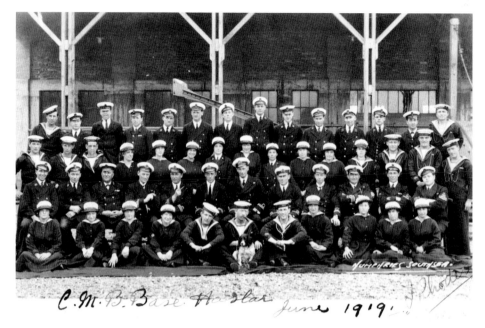

The Coastal Motor Boat base at Haslar, June 1919. Renamed HMS *Hornet* in 1925, it closed the following year but was re-established in 1939 and remained as a Motor Torpedo Boat base until 1958. This group includes Wrens – members of the Women's Royal Naval Service – which was established in 1917 but disbanded soon after this photograph was taken.

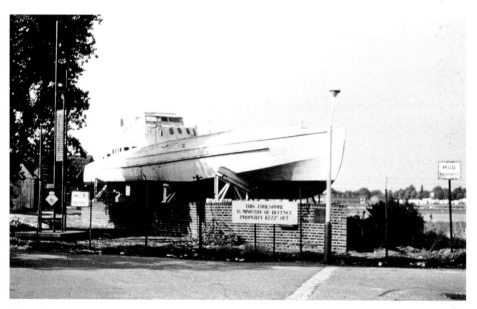

Coastal Motor Boat 103 on display near Haslar Bridge in the 1970s. Built by Camper & Nicholson in 1920–21, this craft served off the Normandy beaches during D-Day. These fast torpedo boats were originally designed to skim over enemy minefields and attack German shipping in the First World War.

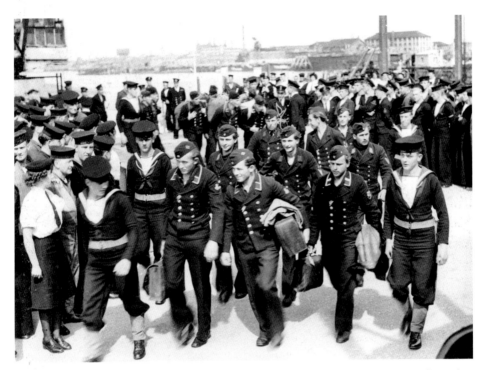

Prisoners-of-war at HMS *Dolphin*, 1945. Crew members from captured E-Boats smile as they disembark, perhaps relieved that, at least for them, the war is over.

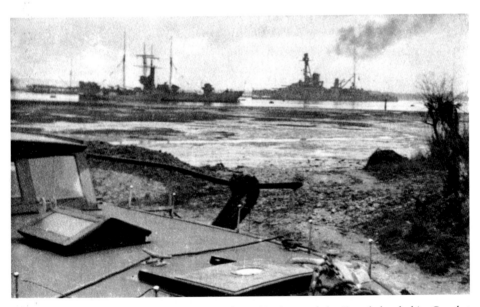

Portsmouth Harbour, *c.* 1940. A rare view from Hardway of the French battleship *Courbet* (*right*), which escaped after the fall of France. It was turned over to the Free French and used as a depot and anti-aircraft ship in the harbour until March 1941. She was subsequently scuttled as a breakwater for Mulberry Harbours in the D-Day campaign.

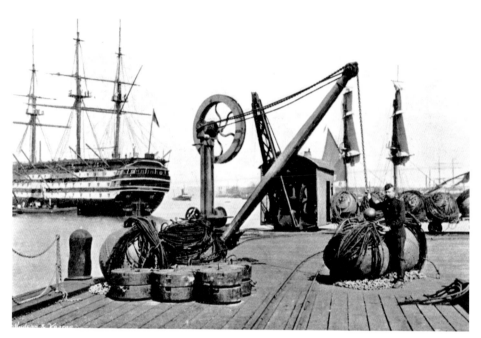

Mines on the Mining Pier, *c.* 1897. HMS *St Vincent* is on the left. In 1873, the Submarine Mining Engineers, a section of the Royal Engineers, was established at Fort Blockhouse, its object being to defend the country's ports against attack using minefields.

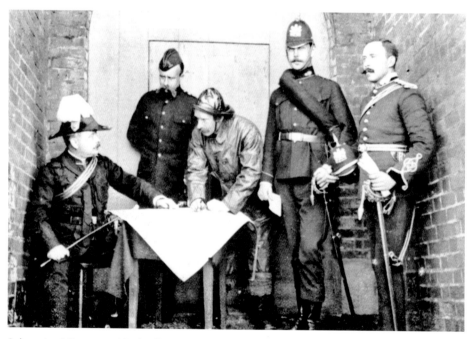

Submarine Miners outside the Guncotton Store, Fort Monckton, *c.* 1897. Testing of mines took place in Stokes Bay off Fort Monckton and Gilkicker. Soon after these photographs were taken, the decision made to phase out mining in favour of a more effective weapon for port defence – the submarine.

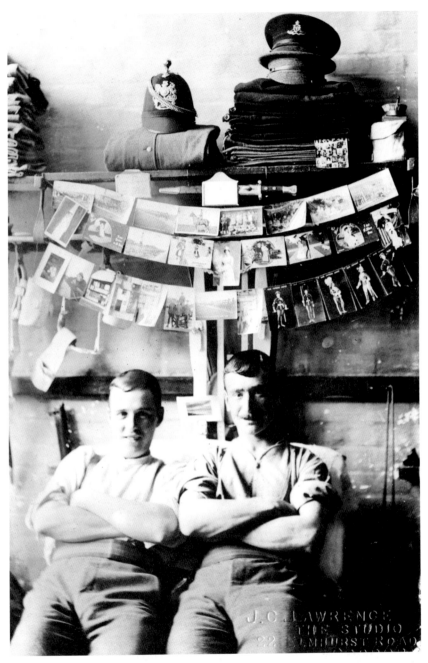

Soldiers in their barrack room, captured by Gosport photographer J. C. Lawrence in around 1910. They are surrounded by pin-ups of the day's music hall stars.

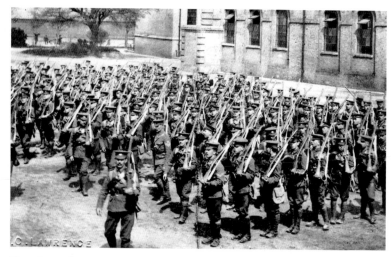

New Barracks, *c.* 1910. Soldiers are seen here being dismissed following a route march, watched by children through the iron railings at the far end of the parade ground. In the 1870s, there was concern that the railings were too far apart when an enterprising ten-year-old boy was charged with smuggling spirits into the barracks, bypassing the sentries.

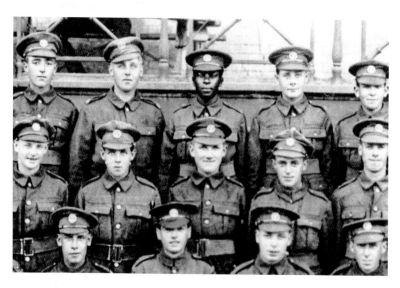

An unknown black soldier belonging to the 18th Squad of the 3rd Battalion of the Hampshire Regiment at New Barracks (later St George) in 1918. This battalion was based in Gosport between 1915 and 1919 for training and as a rehabilitation centre for wounded men before they were sent back to active service. 500 officers and 22,000 men based at these barracks were sent to fight during this period. As well as the relatively few black soldiers who served in British regiments, more than four million men and women from Britain's colonies volunteered, and 140,000 Indians served on the Western Front. Sadly, tales of discrimination and hardship of soldiers from non-white ethnic groups who fought for King and Country were very common.

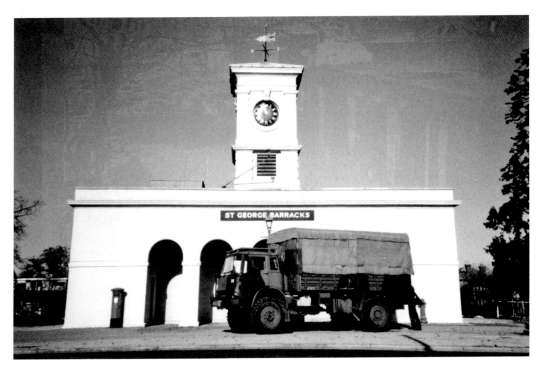

St George Barracks, 1990, showing the former guardhouse. The last regiment to occupy the barracks – the 2nd Maritime – arrived in 1971 but in 1991 the barracks were deemed surplus to requirements.

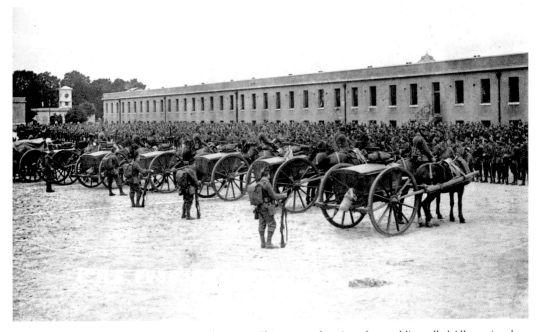

Royal Scots Fusiliers at New Barracks, 1914. This postcard, written by a soldier called Albert nine days after war was declared, describes how the 11,000 men were ready for Active Service.

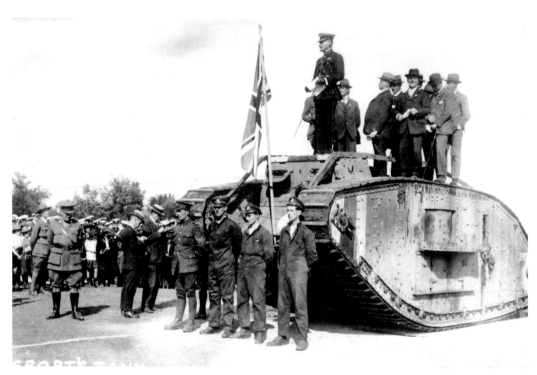

Gosport's tank was presented to the town shortly after the First World War and was on display for many years in Gosport Park.

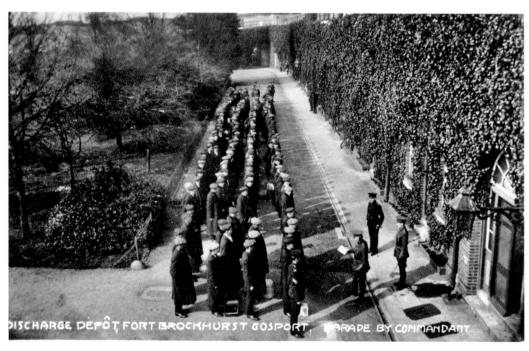

Demobilised soldiers on parade at Fort Brockhurst, a major discharge depot, *c.* 1919.

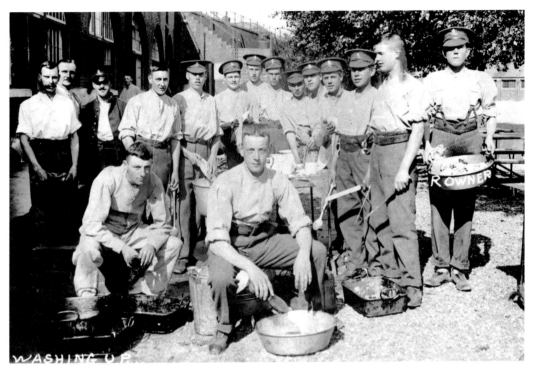

Washing up at Fort Rowner, *c.* 1910.

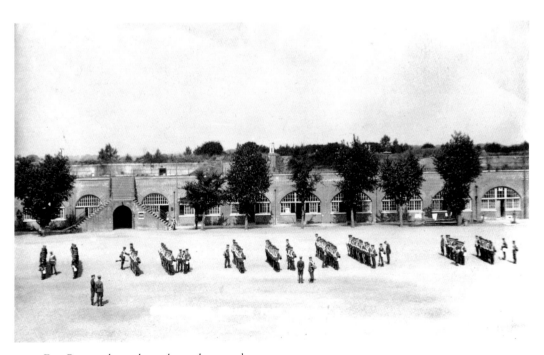

Fort Rowner barracks and parade ground, *c.* 1910.

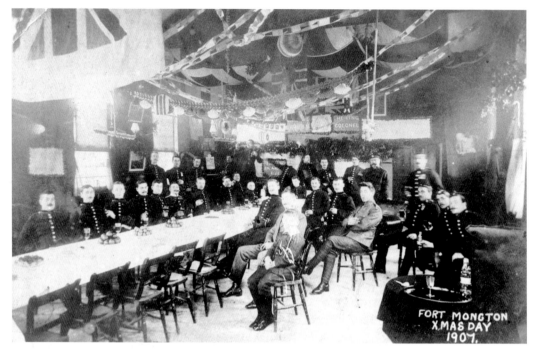

Christmas day at Fort Monckton, 1907. During the First World War the fort was used as a searchlight battery and armed with a maxim gun on a parapet carriage. The fort has reportedly been retained as a military training base where MI6 officers undertake small arms training and courses in methods of espionage.

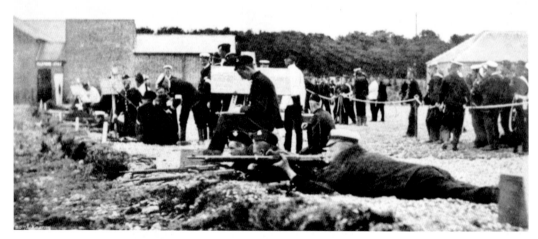

Inter-service Rifle meeting, Browndown, July 1899. During this four-day competition it was noted that 'the shortcomings of the infantry field cap as a protection for the eyes from the glare of the sun' became very apparent.

Second World War anti-aircraft site, Holbrook,
c. 1940. A 4.5-inch anti-aircraft gun, manned
by the army, was mounted a few hundred yards
north of Brockhurst junction, one of three
such gun sites built to protect Portsmouth, the
others being at Fort Gilkicker and at Sinah,
Hayling Island.

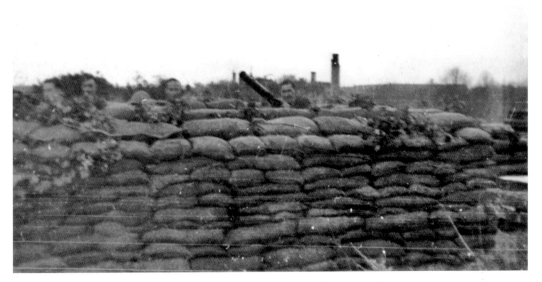

Sandbagged and manned gun emplacement, c. 1939, possibly at Fort Grange.

Royal Airforce Base, Fort Grange, Development Flight, 1928.

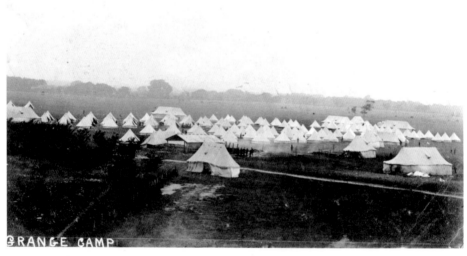

Grange Camp, 1909, a view from Fort Grange on a postcard sent by a soldier under canvas. Pioneering glider experiments were carried out by local submariners on this land at this time. In 1910, the Hampshire Aero Club successfully negotiated formal use of the site and a wind tunnel was constructed at Fort Grange. It was claimed that the first ever stability curves of aircraft were established here. Three gracefully efficient gliders were the result, reaching a height of 50–60 feet and travelling up to 400 yards, helped by sturdy local youths who hauled on ropes to propel the aircraft.

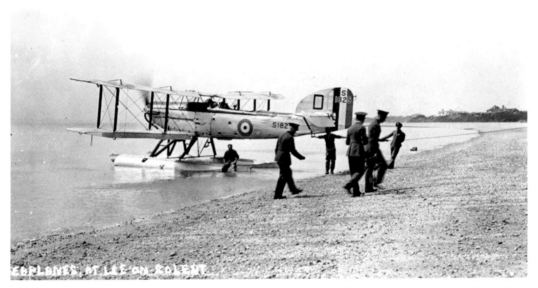

On the beach at Lee-on-the-Solent, early 1930s. The Fairey IIIf was the most widely used aeroplane in the Fleet Air Arm between the wars and was used to train observers at Lee. They were also bravely employed in towing targets to provide the Royal Navy with gunnery practice.

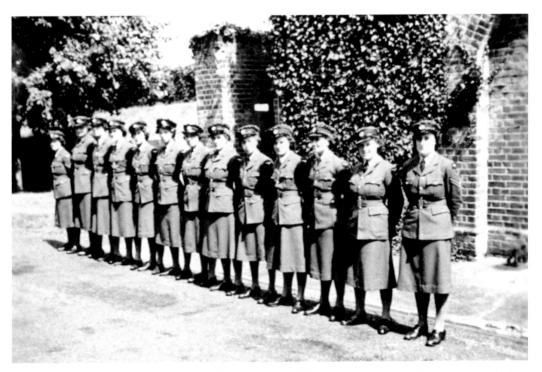

WAAFs at Fort Grange, c. 1940. At this time, No. 17 (Training) Group was under the command of Air Commodore TEB Howe.

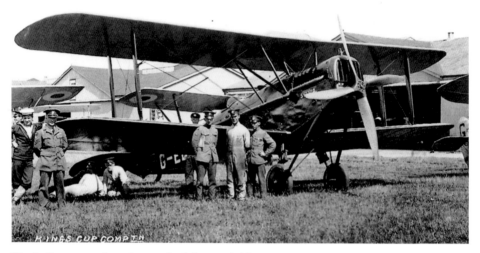

King's Cup contenders, Lee-on-the-Solent airfield, 1924. In 1922, King George V offered this trophy to help encourage the development of British light aircraft and engine design. The cup was won in 1924 by Mr Alan Cobham who completed the 950 mile flight at an average speed of 106 ½ mph in a de Havilland DH 60 Moth.

The Duke of Kent (*centre*) makes a morale-boosting wartime visit to Fort Grange, *c.* 1940. The Duke was killed in 1942 when the flying boat in which he was a passenger flew into a hillside near Dunbeath.

People

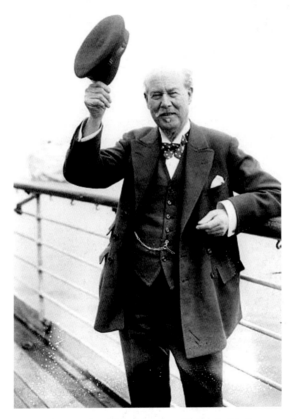

Thomas Lipton was a merchant and avid yachtsman who made his fortune with the Lipton tea brand. His persistence in challenging for the America's Cup brought commissions for yacht-builders Camper & Nicolson and the building of *Shamrock IV* (1914) and *Shamrock V* (1930) provided a major boost to the local economy between the wars. Gosport was put on the map by the world's media as a result of the yacht launches, an interest heightened by the intense rivalry with the United States. Lipton failed to win the cup, but received a 'best of losers' trophy. As a self-made Scotsman who lacked airs and graces, Lipton was not accepted by the Royal Yacht Squadron until shortly before his death in 1931 (see also page 85).

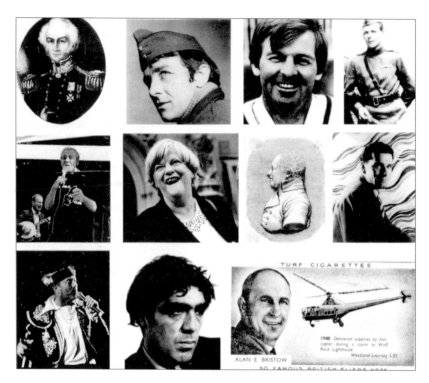

TOP (LEFT TO RIGHT):

Admiral Francis Austen, brother of Jane Austen, was a founding member of the Floating Bridge Company and became its chairman.

Colin Emm, born in Gosport in 1932 married actress Diana Dors, moved to California and, as **Dickie Dawson** is famous for his role in comedy series *Hogan's Heroes*. A less famous but prolific actor, Arthur Malet (not pictured), born in Lee-on-the-Solent in 1927, also succeeded in Hollywood specialising in playing elderly roles. He appeared in *Mary Poppins* and many series, from *The Untouchables* to *Dallas*.

Cricketer **Trevor Jesty** was born in Gosport in 1948 and played for England and Hampshire in the 1970s and 1980s.

Robert Smith-Barry pioneered the development of flying training methods at Fort Grange during the First World War.

MIDDLE:

Nat Gonella, the famous jazz trumpeter, lived in Gosport from 1977 until his death in 1998.

Ann Widdicombe, former Tory politician, attended Bridgemary school for a short while in the 1950s. Her family lived in Ordnance House, Fareham Road.

Henry Cort, the great iron founder, lived in Gosport from around 1777 and patented the puddling process. His iron foundries facing The Green in Gosport (and Fontley) supplied the Navy.

Laurence Olivier trained as a pilot at the Royal Naval Air Station, HMS *Daedalus,* at the start of the Second World War.

BOTTOM:

Keith Allen, actor, film-maker and son of a submariner, spent most of his childhood in Gosport and attended Brune Park School.

Jonathan Routh was born in Gosport in 1927, and became the first television prankster in Britain in 1960 when he made *Candid Camera*, which ran for seven years.

Alan Bristow, the pioneering helicopter pilot and entrepreneur, did his initial training at HMS *St Vincent* during the Second World War.

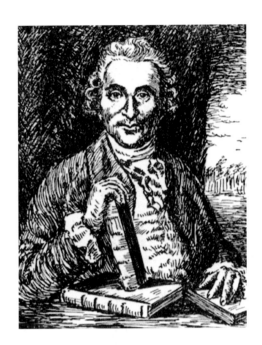

In 1758, James Lind was appointed physician to Haslar Hospital where he investigated the distillation of fresh water from salt water for use at sea. He is best known for his work in 1747 when he investigated the cause of scurvy amongst seamen, and established that citrus fruit was the only effective remedy.

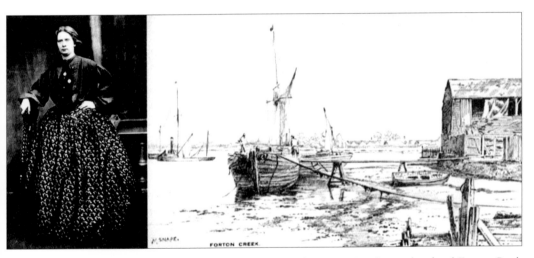

Jessie Meriton White was born in Gosport in 1832 and grew up in a house that faced Forton Creek (seen here in drawing by Martin Snape, c. 1890), where she enjoyed messing about in boats with her brothers. 'My delight was to be on the lake – sunshine, salt water and the lake were a pure joy,' she wrote, 'but the lake at low tide was to be avoided, being all mud and nastiness to eye and nose'. She was a rebellious child who acquired a reputation for being insufficiently ladylike. Her father was a shipwright who appears to have run his business from Little Beach Street. The family were passionate about education and extended that to include their daughter – unusual at a time when females were generally excluded. Jessie applied to study medicine but was rejected because of her sex and so took up writing and journalism. She became a radical and a great advocate of Italian unity, befriending Garibaldi and joining his campaign in 1860 as a nurse. She became a revolutionary saint in Italy, was imprisoned twice and married fellow activist Alberto Mario. 'Garibaldi's Englishwoman', as she became known, had flaming hair and smoked cigars. She wrote about and campaigned against poverty and exploitation and remains a heroine in Italy. She died in 1906.

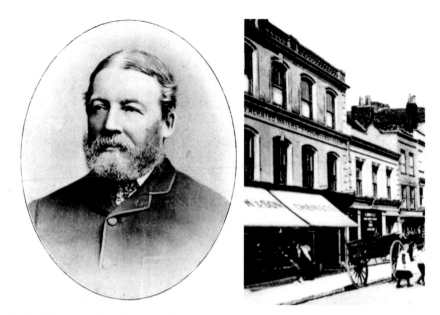

Charles Mumby was listed as one of four chemists trading in Gosport High Street in 1852. By 1865 he had diversified into making soda water and by 1875 had branches at Forton, Portsea and Portsmouth. By 1895 he had dropped the pharmaceutical side of his business and was listed as a 'mineral water manufacturer and ice merchant' at No. 48 High Street (seen here next door to W. B. Smith the chemist). Mumby's Mineral Water Factory was at the Green and water used in the production of Mumby's original soda water and other soft drinks was drawn from an artesian well, which penetrated 300 feet below the factory. By 1906, Mumby had royal endorsement and his advertising cited 'by special appointment to His Majesty King Edward VII'. A *bon viveur* with great appetites, the King was not well known for his consumption of soft drinks. Sadly, Mumby's went out of business after 1967, too early to benefit from the bottled water boom.

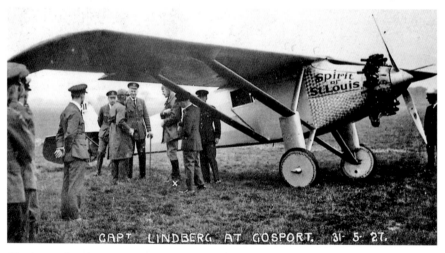

Charles Lindbergh at Grange Airfield, 1927. A few days after completing the first non-stop flight from New York to Paris in 1927, celebrated aviator Captain Lindbergh (marked with an 'X') dropped in at Grange Airfield in his monoplane, *The Spirit of St Louis*.

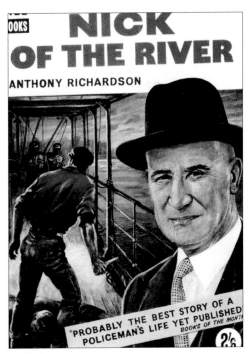

NICK OF THE RIVER

ANTHONY RICHARDSON

"PROBABLY THE BEST STORY OF A POLICEMAN'S LIFE YET PUBLISHED" BOOKS OF THE MONTH

2/6

David Nixon was born in 1894 and brought up in married quarters in the New Barracks (later St George Barracks), the son of a rifleman. In 1901 his father died, leaving his mother to bring up three children. In 1955 'Nick's' biography was published, describing his thirty-four-year career in the Metropolitan Police, of which twenty years were spent in the Thames Police. Nixon organised the detection of crime for the whole of London's riverside docks and dealt with suicides, drug trafficking, murder, theft, and smuggling. His stories inspired a television series in 1959, in which he was played by George Baker, thirty years before his acclaimed portrayal of Inspector Wexford.

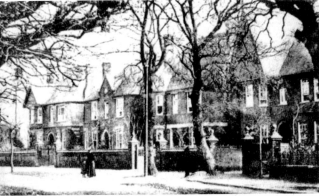

John Barron was born in 1920 in Marylebone, and was brought up by his actress mother. He attended Edinburgh House School, Lee-on-the-Solent, from the age of ten until fourteen. This school was given its name by the Scottish headmaster who took over the premises in Manor Road, which had previously been the Royal Naval School. Barron attended Portsmouth Grammar School in 1935, and RADA in 1938, gaining experience in repertory companies before wartime service in the Royal Navy as a Lieutenant. Following demobilisation, Barron returned to directing in rep, but was offered more substantial roles in the West End. In the late 1950s, he landed his first regular television role in *Emergency Ward 10*, the first successful soap. He went on to feature in many well-known television series of the next three decades including *The Avengers, The Saint, Softly, Softly, Timeslip, Doomwatch, Shelley, To the Manor Born, Crown Court, Whoops Apocalypse, Potter, Yes, Minister* and of course the *Reggie Perrin* series in which he played the booming C. J. who 'didn't get where he is today'. He became active in the actors' trade union, Equity, and served as president for four years. John Barron died in 2004.

Oliver Upfield set up his linen and drapery business in North Street in the middle of the nineteenth century. The business passed to his son, James Oliver Upfield, who had five sons; the eldest of whom, Arthur Upfield, was born in 1890. With no aptitude for commerce, Arthur was packed off to Australia in 1910 by his frustrated father. Arthur was writing unpublished novels, but realised that he had to make a living. He tried his hand at many jobs including cowhand, sheepherd, gold-miner and fur-trapper and also fought in the First World War. In 1928, he published his debut novel, which was soon followed by the first Detective Inspector Bonaparte story, *The Barrakee Mystery*. The character was based on a half-aboriginal friend. The 'Bony' stories were bestsellers and were adapted for a television series in the early 1970s as *Boney*. A German songwriter and fan reportedly named his band Boney M after the character. Following his death in 1964, *The Times* paid tribute to Upfield, saying that 'few other writers have brought a seemingly lifeless desert more colourfully to life or been more successfully in communicating the unexpected beauty of Australia's hills and forests and rocky coasts.'

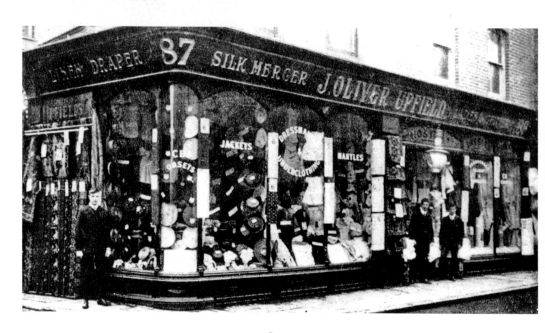

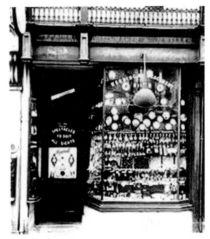

Hug's the jeweller has had a presence in Gosport High Street since the 1890s, when William J. Hug, the son of a Swiss immigrant, won naval contracts to repair and service chronometers, barometers and clocks. The business at 82 High Street grew, later moving to No. 90 and adding branches at 53 Stoke Road, Fareham and Ventnor. One of William Hug's grandsons, Mike, briefly worked in the company's workshop before forming the pop group Manfred Mann. Mike co-wrote many of the group's hits. Initially a drummer and percussionist, he went on to play keyboards and wrote music for film and television, including *Up the Junction* and the theme to *Whatever Happened to the Likely Lads*. Mike's younger brother Brian, who currently runs the Gosport and Fareham shops with his family, is also a musician and co-wrote the Yardbirds' 'Mister You're a Better Man than I'.

Joe Jackson was born in Burton-on-Trent in 1954. His family moved to Portsmouth the following year and Joe was brought up in Paulsgrove until the age of fifteen when they moved to Bridgemary. He began playing gigs while still at school and at the age of eighteen studied classical piano at the Royal Academy of Music while still living in Gosport. His hits include 'Is She Really Going Out With Him?' and 'Steppin' Out'.

Stephen Weeks, who made his name as a sixteen-year-old campaigner against the demolition of historic buildings in Gosport (see page 127), went on to become a film director, producer and writer. While still at Portsmouth Grammar School he made films on threatened buildings for Southern Television and BBC South, as well as *The Camp*, which featured school friends, and was filmed at the disused army camp on Browndown. Weeks went on to direct *I, Monster* starring Christopher Lee and Peter Cushing, and *Sword of the Valiant: the Legend of Sir Gawain and the Green Knight*, with Sean Connery and Trevor Howard. He has continued his passion for history and historic buildings, and is currently writing novels and renovating castles in Prague.

Roger Black was born in Portsmouth in 1966 but was brought up in Alverstoke. Before his voice broke, he was head choirboy at St Mary's church. A sporty lad, he played centre-forward for Alverstoke Junior School team and took part in the Gosport Schools Cup, losing to Elson School 2–1. At Portsmouth Grammar School, Roger loved rugby and was selected for an England under-16 trial, but began to excel as an athlete, taking part in the English Schools' Athletic Championships. During his subsequent athletics career, he won individual silver medals in the 400 metres sprint at the Olympic Games and World Championships, two individual gold medals at the European Championships, and 4x400 metres relay gold medals at both the World and European Championships. Since retiring from athletics, he has worked as a motivational speaker and television presenter, as well as making celebrity appearances on programmes such as *Strictly Come Dancing* and *Celebrity Masterchef*.